# FRONTIERS REIMAGINED

## ART THAT CONNECTS US

### 44 ARTISTS | 25 COUNTRIES

56. Esposizione
Internazionale
d'Arte
Eventi Collaterali

la Biennale di Venezia

# FRONTIERS REIMAGINED

## ART THAT CONNECTS US

### 44 ARTISTS | 25 COUNTRIES

Marsilio

Publication issued in conjunction
with the exhibition
*Frontiers Reimagined*
May 9 to November 22, 2015
Museo di Palazzo Grimani, Venice
Collateral Event to the 56th International Art
Exhibition La Biennale di Venezia

**Exhibition presented by**

**Under the aegis of**
Ministero dei Beni e delle Attività Culturali
e del Turismo
**Ministro**
On. Dario Franceschini

**With the support of**

University of **Portsmouth**

frame visual art finland

**Tagore Foundation International**

**Commissioner and Curator**
Sundaram Tagore

**Co-Curator**
Marius Kwint

**Coordinating Director**
Nathalie Vernizzi

**Publications Director**
Kelly Tagore

**Organizational support in Venice**
Mario Di Martino,
Studio Antonio Dal Ponte

**Technical Consultant**
Zattera Marangon Associati Architects

**Transportation/Installation**
Apice, Ott Art, Venice

**Polo Museale del Veneto**

**Director**
Daniele Ferrara

**Director Museo di Palazzo Grimani**
Giulio Manieri Elia

**Vice-Director Museo di Palazzo Grimani**
Maria Cristina Dossi

**Technical Office**
Annunziata Genchi
Giulia Passante
Mauro Tarantino

**Exhibition Office**
Carla Calisi
Francesca De Pasquali

**Press and Communication Office**
Sandra Rossi
Valter Esposito
Roberto Fontanari

**Secretarial Staff**
Lorena Muran
Ornella Urban

**Exhibiting Artists**
Miya Ando
Alfredo and Isabel Aquilizan
Osi Audu
Frances Barth
Edward Burtynsky
Kamolpan Chotvichai
Christo
Tom Doyle
Golnaz Fathi
Olivia Fraser
April Gornik
Denise Green
Sasha Huber
Georges Fikry Ibrahim
Fré Ilgen
Kenro Izu
Kim Joon
Nathan Slate Joseph
Aaron Taylor Kuffner
Jane Lee
Tayeba Begum Lipi
Hassan Massoudy
Vittorio Matino
Ricardo Mazal
Vik Muniz
Judith Murray
Michael Petry
Robert Polidori
Chatchai Puipia
Sohan Qadri
Robert Rauschenberg
Sebastião Salgado
Nino Sarabutra
Hiroshi Senju
Donald Sultan
Jack Tworkov
Lee Waisler
Susan Weil
Morgan Wong
Robert Yasuda
Chun Kwang Young

Design and editing Studio Bosi, Verona
© Denise Green, Hassan Massoudy,
Vik Muniz, Robert Rauschenberg,
Jack Tworkov by SIAE 2015
© 2015 by Marsilio Editori® spa in Venezia
Text © 2015 Tagore Foundation International
First edition April 2015
isbn 978-88-317-2193

www.marsilioeditori.it

# Foreword

**Giovanna Damiani**
Former Superintendent for the Patrimonio
storico, artistico e etnoantropologico
e per il Polo museale della città di Venezia
e dei comuni della Gronda lagunare

On several occasions we have described what appears to us to be of vital importance for a cultural institution: that is finding its own vocation, since having a specific identity on the crowded Venetian cultural scene is even more crucial than elsewhere. Throughout the year umpteen initiatives of an increasingly higher standard are offered to Venetians and visitors by public and private institutions. Moreover, there has often been talk of what should be the positioning on this busy scene of the five state museums that come under the Venice Soprintendenza Speciale.

To begin with the Gallerie dell'Accademia, the opening of the first rooms in the new ground-floor wing in early May will strengthen its leading role in furthering knowledge about the Veneto and Venetian art heritage by displaying many works never previously shown to the public from less well-known periods such as the seventeenth and eighteenth centuries. At the same time it is opening up its wealth of preserved collections to the latest technological means adopted for guiding visitors and educational activities, thus ensuring a future of growing international renown and success. The Galleria Giorgio Franchetti at the Ca' d'Oro, on the other hand, is a temple to collecting and private patronage that became a public patrimony at the behest of its founder. The museum's cultural policy made a resolute move to attract a wider public with the exhibitions of 2013 and activities since then to showcase its collections involving promoting events and initiatives, such as the most recent conference, "The Ca' d'Oro of Giorgio Franchetti. Collecting and Museology."

The Museum of Oriental Art is still a unique institution on the Venice art scene. The oldest of its kind in Europe, it houses a stunning collection of Japanese, Chinese and Indonesian art, which is among the finest worldwide. It has not yet fully expressed its potential because of a lack of space, and its storerooms are still overflowing with artefacts rarely exhibited or only for brief periods. We believe that we have now found a future home for these items that will ensure better use is made of them in even livelier cultural projects.

Now part of the St Mark's circuit, the National Archaeological Museum was founded with collections of Roman classical art and, most importantly, a large number of original Greek items, at the behest of Domenico and Giovanni Grimani. Today it attracts growing public interest and enjoys considerable popularity. As regards the Palazzo Grimani Museum, from the outset I have always argued that its vocation should be to provide a vital, dynamic place for culture, a thoroughgoing cultural workshop, in which to admire its imposing architecture and to stage or host all kinds of art shows and so create virtuous circles of exchanges and dialogue between the arts. On the subject of this our latest museum to be opened to the public, I have often spoken of a "House of the Arts," in which all art forms can find an ideal place in a harmonious dialogue as a homage to the family responsible for rebuilding the palace in its current form in the mid-sixteenth century and their collections of art, sculptures, painting, medals and coins; not to mention the invaluable bibliographical

heritage—unique in Venice—reflecting their vast musical and literary interests. The very complex family and artistic history of the Grimani reveals an open-minded approach to cultures that were different and unusual for Venice, in fields that ranged from northern European to Tuscan-Roman art.

In the spaces on the second-floor *piano nobile* of the Palazzo Grimani, previously closed to the public, after the costly, thorough refurbishing carried out in recent years, we are in a position to broaden further the varied cultural offering systematically and continuously, leaving the first floor for the now historical itinerary. To underscore this new opportunity to showcase the museum, on 9 May 2015 a contemporary art exhibition will be inaugurated on the second floor of the palace as one of the Collateral Events in the 56th International Art Exhibition of La Biennale di Venezia. Entitled *Frontiers Reimagined*, the exhibition has been organised by the Tagore Foundation International in close collaboration with this Soprintendenza. When presented over a year ago, the international project appeared to be extremely interesting in terms of the theme to be explored, associated with the concept of cultural frontiers as addressed by both promising and well-established artists worldwide. This foray into contemporary art is not unusual for the Palazzo Grimani. In 2013, for example, the palace hosted a very refined show of works by Ritsue Mishima during the 55th International Art Exhibition. On that occasion the artist specifically designed and made glass objects that would relate to the pictorial and sculptural decoration of the palace.

At a time when different cultures are engaged in dialogue and crossed over as never before, the phenomenon of globalisation offers a rich, complex source of inspiration for artists. This complexity is tackled in sculpture, painting, installations and photography by artists from Asia and Africa as well as from the West, which illustrate the intellectual and aesthetic achievements of artists exploring different cultures from their own.

Inspired by the Tagore Foundation's principles of encouraging dialogue between East and West, the theme of this latest exhibition has an ideal setting in Venice, with its centuries-old tradition of trade and cultural relations involving countries in the Near and Far East. Long considered the Western world's gateway to the East, Venice can offer the best contextualisation for the values informing the foundation's key principles, which we have come to appreciate greatly in these months of collaboration.

The artists featured in this exhibition live and work in different cultures but share a genuinely global outlook. This endows their various art forms with dynamism and a twofold nature, as they blend elements from their own culture of origin with "other" cultures as a whole. They express themselves with a variety of ideas, techniques and media, which I am convinced will create a fertile ground for debate and will be fittingly highlighted in the lively cultural environment of the Biennale.

# Acknowledgements

**Sundaram Tagore**
Curator *Frontiers Reimagined*

Exhibitions are collaborative undertakings, and *Frontiers Reimagined* is no exception. If it is unique, it is only because of the extraordinary dedication and energy of those who have helped to realize it.

The seeds of this exhibition were planted more than twenty-five years ago when I spent a summer in Venice as a graduate student working at the Peggy Guggenheim Collection, funded by a scholarship from the Italian Ministry of Culture. It was my introduction to the wonders of Venice and to the Biennale. I was fascinated then, as now, by the city's enduring tradition of cultivating cultural relationships with the East. Venice was the very embodiment of the cross-cultural dialogue that was driving my studies, and later, would inspire my career as a gallerist. I dreamt of one day staging an exhibition in Venice that would bring together the work of artists who were deeply engaged with cultures other than their own.

Dreams and reality are two different things, however. And my dream would not have become the reality of *Frontiers Reimagined* without Nathalie Vernizzi, the exhibition's coordinating director. An art historian, author and organizer par excellence, she has been instrumental in bringing this project to life. I have her to thank for the introduction to Mario Di Martino that led to our glorious venue—the Museo di Palazzo Grimani—and for navigating our status as a Collateral Event of the 56th International Art Exhibition of La Biennale di Venezia. Her knowledge of Venice and the intricacies of mounting an exhibition in such a unique environment, of the workings of the Biennale, and of course, the art itself, have been a godsend. For all of this and more, I owe her my deepest gratitude and thanks.

My heartfelt thanks, too, go to my staff in New York, Hong Kong and Singapore. They worked side-by-side with Nathalie Vernizzi over the past year to meet what seemed like un-meetable deadlines. I am especially grateful to Julia Occhiogrosso, who oversaw the monumental task of coordinating the exhibition's forty-four artists and insuring their works arrived safely in Venice from points all over the globe. Thanks, too, to our talented and hardworking media and publications team, including publications director Kelly Tagore, graphic designer Russell Whitehead, media coordinator Kieran Doherty, publications coordinator Angela Sen and Payal Uttam. I am grateful for the expertise and hard work of our head preparators, Stanley Lee and Andy Hui, who so diligently and carefully handled the precious works of art in this exhibition. And for invaluable administrative support, my thanks go to Barbara Eagle Westerink, Hilary Ma, Benjamin Rosenblatt, Raj Sen, Esther Bland, Emma Battaglene, Chelsea Zhao and Ichin Zinn. I was able to so thoroughly devote myself to this exhibition and see it realized on such a grand scale thanks to the hard work of Faina Derman, Susan McCaffrey, Teresa Kelley, Melanie Taylor, Bonnie B. Lee and Deborah Demaline.

We are all the wiser for having Marius Kwint as co-curator. As an academic, author and curator, he brings a wealth of art historical expertise to bear. Over many years of friendship I have always known

him to be exceedingly generous with his time and his insights and he certainly did not disappoint on that front over the past year. I am most grateful for the incisive and thought-provoking text he has contributed to this catalogue and for the knowledge he has shared so willingly. I would also like to thank the University of Portsmouth, where he teaches Visual Culture, for supporting his involvement in this project.

We are extremely fortunate to have many supporters around the world who have enthusiastically championed this exhibition. In New York I would like to thank Hiromi Senju and Hiroshi Senju for their unwavering generosity and Polskin Arts & Communications for their media expertise. In Hong Kong, I would like to thank Nelson Leong, chairman of the Board of Governors of the Hong Kong Arts Centre, who has been a longtime patron. We share with him and the HKAC the goal of promoting contemporary art and culture in Hong Kong through exhibitions and art education.

In Singapore I wish to thank Katherine Kwun McLane and Willard McLane for their enthusiasm and ability to bring people of common interest together; longtime supporters Rebecca Woo and Kevin Dwan; and Uma Parameswar for her assistance in the early stages of this exhibition.

In Venice, we have encountered an abundance of help in mounting *Frontiers Reimagined*. I would like to express my gratitude to Giovanna Damiani, former superintendent for the Patrimonio storico, artistico e etnoantropologico e per il Polo museale della città di Venezia e dei comuni della Gronda lagunare. Her willingness and efforts to overcome obstacles has been admirable and we have never wanted for her support. My deepest thanks to Nunzia Genchi, the architect of Museo di Palazzo Grimani, with whom we have established a superb working relationship. I greatly appreciate her efforts to overcome the inevitable challenges of installing contemporary works of art in such an ancient and venerable building and her readiness to solve problems big and small. My thanks also go to Giulio Manieri Elia, the museum director, and to the museum staff, in particular Giulia Passante. Thanks also to Mauro Tarantino and the ever-helpful museum attendants and security staff.

I am also most obliged to the staff of the Polo museale del Veneto, who have worked in close collaboration to prepare and promote *Frontiers Reimagined*, in particular Carla Calisi, Roberto Fontanari and Sandra Rossi. Thanks, too, to Maria Cristina Dossi, who kindly agreed to write an introductory text for this catalogue, which has helped acquaint us with the complex history of the museum.

Over the past two years, many people in Venice have provided invaluable assistance to my team and they are very much a part of the success of this project: Lisa Angaran, Rino Cortiana, Mario Di Martino, Silvia Marri and Maurizio Torcellan. I would also like to extend sincere thanks to our lawyer, Manlio Frigo, Ludolex, Milan, for his keen and expert guidance.

When it came time to gather the work for this exhibition, we were

aided in many quarters. I would like to thank the private collectors who generously lent works, including Frank Cassou and Gabrielle Cassou; Hart Perry for lending a painting by Jack Tworkov and to Jason Andrew for organizing that loan; and Nirmalya and Maya Kumar for lending paintings by the Tagores and Amit Roy for facilitating that loan. I would also like to thank the gallerists and galleries who kindly offered their cooperation, especially Cesar Villalon of The Drawing Room, Makati City, the Philippines, and Singapore, who facilitated the participation of Alfredo and Isabel Aquilizan; and Yesim Turanli of Pi Artworks, Istanbul and London, for her assistance securing the work of Tayeba Begum Lipi. Thanks, too, to Danese/Corey gallery, New York, which represents April Gornik; and Galerie Karsten Greve, St. Moritz, Paris and Cologne, which represents Robert Polidori in Europe.

I am indebted to Frame Visual Art Finland, which sponsored Sasha Huber's participation in this exhibition; to curator Loredana Paracciani for introductions to Kamolpan Chotvichai, Chatchai Puipia and Nino Sarabutra; to curator Karin Adrian von Roques who first brought Golnaz Fathi, Georges Fikry Ibrahim and Hassan Massoudy into my orbit; to Alia Swastika who assisted in organizing the work by Eddi Prabandono; and to Christopher Rauschenberg, David White and the Robert Rauschenberg Foundation for making available the work of Robert Rauschenberg, one of the first modern artists who opened my eyes to the possibilities of globalism.

Finally, I am exceedingly grateful to each of the artists in this exhibition, many of whom have created work especially for it. They are a constant source of inspiration and it is their incredible abilities to give form to ideas that make this undertaking possible.

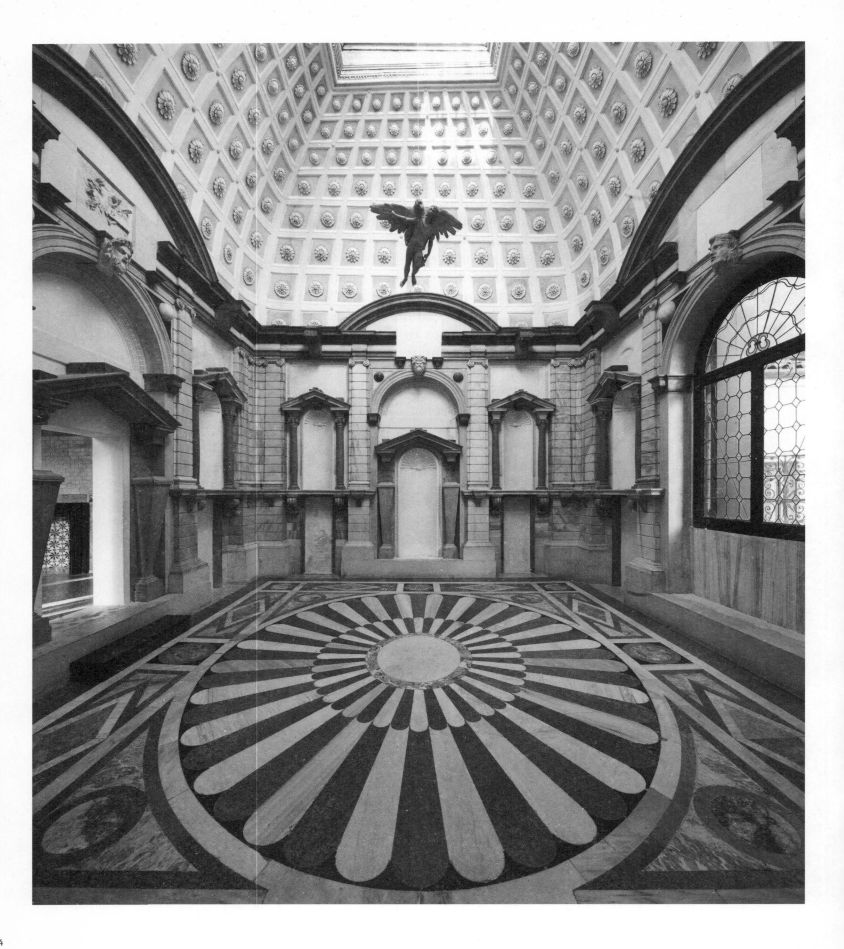

## About the Palazzo Grimani

**Maria Cristina Dossi**
Vice-director
of the Museo di Palazzo Grimani

The Tagore Foundation exhibition entitled *Frontiers Reimagined* is installed on the second floor of the Palazzo Grimani. This is the first time these rooms have been opened to the public and they host a show featuring more than forty artists in one of the most important Collateral Events at the 56th International Art Exhibition of La Biennale di Venezia.

The decision to bring together Tagore Foundation and the Palazzo Grimani also aims to highlight how over the centuries various artistic languages have conveyed a timeless passion for art independently of differences in media and techniques.

The Grimani were a Venetian family that rose to its greatest power in the sixteenth century. They pursued a very special art policy compared to mainstream art in the Venetian Republic at the time by introducing a language that often reflected the Renaissance modes and Mannerism of central Italy.

The family history of the Grimani reveals some fascinating aspects of their collecting interests. The palace had an important collection of Venetian antiquities (now partly in the Venice Archaeological Museum) and a rich collection of gems, books, miniatures and a selection of sixteenth-century works, unfortunately dispersed.

The initial building was constructed at the confluence of two canals, the Rio di San Severo and the Rio di Santa Maria Formosa, in the Byzantine Veneto period, before the year 1000. Much smaller than today's building, the original palace had a peculiar masonry texture, part of which has survived but can only be seen by observing the palace from the canals.

In the fifteenth century the building was extended toward what is now Ruga Giuffa (with the current main entrance), while another part was added along the Rio di San Severo: here, too, there are some surviving remnants with the typical late Gothic use of bricks. At this time the original rooms were also renovated.

The building's present-day appearance is due to work carried out by the Grimani family. In the sixteenth century the old *casa da stazio* (a specific type of merchant's house) was transformed into a patrician palace meant to vie with the full-blown Renaissance architecture of central Italy.

The approach to the building through the *calli* and *campi* of Venice makes the first view of this Renaissance palace even more of a surprise since it is so unlike the rest of the city's "faces." Antonio Grimani, a future doge, acquired the building in 1500 for his family home. In the sixteenth century, Vettore and Giovanni Grimani, Patriarch of Aquileia, began work to remodel it from the 1560s on, also to adapt its rooms for the purposes of displaying a rich collection of antique sculptures, paintings, medals, gems and books.

After entering the building, you reach the courtyard with arcades on all four sides. The architectural forms of the palace show a juxtaposition of languages of various architects, who frequented the residence of Giovanni Grimani (1500–1593). They include Sebastiano Serlio, Jacopo Sansovino

Palazzo Grimani, the *Tribuna*

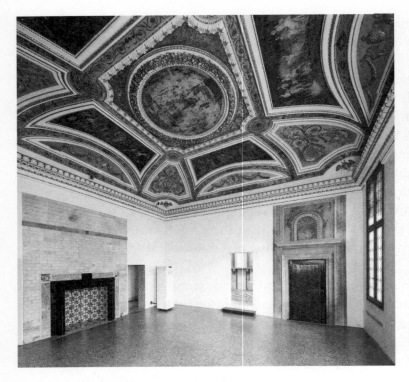
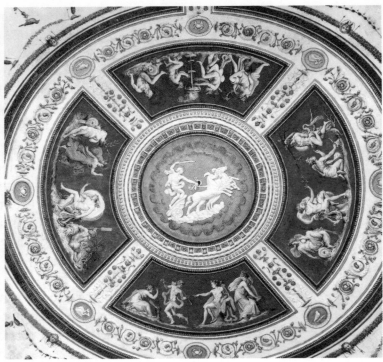

The Neoclassical room
and a detail of the ceiling decoration

and Andrea Palladio, who probably designed the splendid oval staircase.

The architectural and decorative project for the palace, commissioned by Giovanni Grimani, is a kind of homage to the Mannerist culture of central Italy and alludes to the pomp of ancient Rome.

On the *piano nobile* the family history is retold in a symbolic key. Having been accused— unjustly according to the Grimani—of betraying the Republic, the family is depicted in several episodes focused on the injustice that they suffered.

In the *Sala a fogliami* (Foliage Room) the frescoes were painted by Camillo Mantovano in the 1560s to form a "botanic garden" with a great variety of trees and flowers, inhabited by a host of birds and animals. The image of a heron being attacked by a hawk may be an allusion to the story of Giovanni, the patron, who was accused of heresy but then declared innocent at a session of the Council of Trent. The innocent animal triumphs over his aggressor by defending himself, just as the patriarch Giovanni was cleared of the accusations against him without having directly attacked his accusers.

The *Tribuna* is arguably the most spectacular room in the palace. It was conceived as a treasury for the ancient sculptures that once stood in the niches and on the shelves lining the walls. Some of these works are now in the Venice Archaeological Museum, while others were removed at the end of the family's centuries-old history. A lantern with large panes,

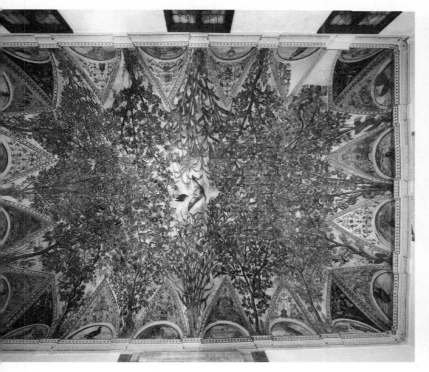

Camillo Mantovano, *Sala a fogliami*,
ceiling and detail

from which an ancient Roman sculpture of the *Rape of Ganymede* hangs,
provides natural lighting for the room and the coffered ceiling, inspired
by Roman models.

The two *camerini* (cabinets) are devoted to the ancient Greek myths
of *Apollo and Marsyas* and *Jupiter and Callisto*. The decoration of these
rooms was designed by Giovanni da Udine, who also did the stuccowork,
and enhanced with frescoes by Francesco Salviati depicting the stories on a
red background and the Ovidian narratives about the god of harmony.
Here, too, the choice of subject is connected to the family history. This is
the fifteenth-century part of the palace and the decoration can be dated to
the 1530s.

In the first *camerino* Marsyas, a satyr, challenges Apollo to a music
contest, unaware that his instrument has been cursed by Minerva. Although
innocent, he is sentenced to be flayed alive by a jury made up of Muses who
are actually members of Apollo's retinue.

In the second room the decoration narrates the story of Callisto. A
nymph at the court of Diana, she is seduced by Jupiter. When she becomes
pregnant, the goddess expels her. She is then further punished by the
jealous Juno who transforms her into a bear. Her son Arcas, also a hunter—
not realising the bear is his mother—tries to slay her. But Jupiter intervenes
and transforms Callisto into the constellation of the Great Bear,
accompanied by her son, the Little Bear, forever.

## About This Exhibition

**Sundaram Tagore**

*Frontiers Reimagined* presents works by established and emerging artists from across the globe who are exploring the artistic entanglements that have manifested with the forces of globalization and dissolution of cultural boundaries.

In keeping with the mission of Tagore Foundation International and the humanistic ideals of Rabindranath Tagore, *Frontiers Reimagined* aims to pose questions about ethnocentrism and identity politics. At this moment in history, with strong currents of toxic nationalism running amok, it seems especially relevant to focus on the dynamic third space—those overlapping points of connection—unencumbered by colonial hang-ups and disparity in order to provide an alternative to the arrangements and assumptions of the 20th century.

The convergence of ideas across borders has never been more necessary. With the flattening of the world, and a shift from a bipolar to multipolar political structure, countries that did not have much of a say in the global political and cultural arenas are gaining a voice—which is reflected in their newfound position in international artistic venues.

In the globalized art world—a microcosm of the globalized world into which we have all been thrust—there is no more top-down authority or hegemonic relationships, but only decentralized points of artistic production and consumption. The positive outcome of this recent reality is that ever-widening swaths of previously local artistic production are gaining exposure and acceptance on international platforms. Another corollary is the growing inclination of artists to actively engage with cultures other than their own on both conceptual and formal levels.

This intensely stimulating and chaotic environment, where cultures are colliding and melding as never before, offers up extraordinarily rich and complex sources of inspiration for visual artists. In *Frontiers Reimagined* we will examine the results of these cultural entanglements through the work of forty-four painters, sculptors, photographers and installation and sound artists, and aim to demonstrate the transformative power and intellectual and aesthetic richness that emerges when artists engage in intercultural dialogue.

Selective cultural and artistic appropriation has been part and parcel of artistic production for millennia: art of the European Renaissance fertilized Indian Mughol painting, Japanese *ukiyo-e* prints helped the Impressionists craft a new visual language and Oceanic and African art certainly impacted the Parisian moderns. But today, this kind of adoption, borrowing and synthesizing is the norm, not just an aspect or branch of the art world.

The artists in *Frontiers Reimagined* share a truly global perspective, both in their physical existence living and working between cultures and in their artistic explorations. They exist in a space that is both transcultural and conflicted, therefore, dynamic, as opposed to a monocultural stasis.

The artists and art in this exhibition come from a vast geographical landscape, stretching from the West to Asia to Africa. The roster includes well-established figures such as Donald Sultan, Hiroshi Senju and Chun Kwang Young as well as artists poised for international recognition, including Jane Lee, Sasha Huber and Tayeba Begum Lipi.

For me, the story of this exhibition begins with *Giallo Call Glut (Neapolitan)*, 1987, the work of renowned artist Robert Rauschenberg because of his early efforts in creating dialogue with cultures deemed peripheral. Rauschenberg was prescient in conceiving the Rauschenberg Overseas Culture Interchange, or ROCI, in the early 1980s, in which he took materials, images and techniques from cultures around the world to use in his art. The resulting works were displayed in Chile, Malaysia and Tibet to name just a few of the stops on the exhibition itinerary. In many ways, it was Rauschenberg, as the first Western artist to personally exhibit in the People's Republic of China, who opened up the idea of avant-garde and installation art for Chinese artists who were generally used to creating work in a social-realist style. For many Chinese artists, the 1985 ROCI exhibition was a revelation. Rauschenberg was the first artist of his stature to initiate a project about peace and understanding through the production of art.

Another early synthesizer was Indian-born modernist Sohan Qadri, who mounted one of his first exhibitions at the Paa Ya Paa gallery in Nairobi in 1966. Qadri began painting as a young man in a small village in the Punjab in the late 1950s, merging Tantric symbols and Western minimalism. Although Tantric imagery was being adapted and scrutinized by influential figures such as Jasper Johns and through the writings of Ajit Mookerjee, Qadri's approach was direct and integral to his painting. He had been initiated into yogic practice as a child, and his painting was a form of meditation. Qadri's work is informed by *Vajrayana* Buddhism and explores the philosophical and artistic tenets of Eastern mysticism. The artist lived and worked in more than twenty countries over his long career before settling in Scandinavia, always refining and furthering a varied and rich dialogue between East and West.

At the other end of the generational spectrum, but very much in the same mold, comes Nigerian artist Osi Audu, a denizen of New York who maintains strong links with Nigeria, Germany, Korea, Japan and the United Kingdom to create intertwining narratives. His quest, like Sohan Qadri's, is the mind or the "inner head" as it's referred to in Yoruba culture—which is consciousness itself, the source of mental equilibrium, health, and destiny in a fragmented and conflicted world.

Many others in the exhibition have emerged from canonical Western modernist educations and backgrounds, including Denise Green, who worked closely with Mark Rothko and other Abstract Expressionists. She has delved deeply into Indian and Australian Aboriginal philosophies to create a personal narrative to contextualize her art and Australia's presence on the global artistic map. Using an integrationist model that deliberately

precludes a monocultural presentation, she's fully convinced that singular or binary presentations cannot teach us anything new in a vastly conjoined and interdependent world.

The brilliant use of color employed by Italian artist Vittorio Matino is informed by his investigations of light and color while living in the Veneto region. He has long been driven to investigate other cultures, which has liberated him from the weight of the legacy of Italy's long and rich artistic tradition. The thrust—and challenge—of Matino's practice has always been the dissolution of cultural boundaries. He has traveled extensively to study Asian and African art and deepen his connection to American Action Painting and Color Field abstraction. His formal investigations, although firmly rooted in the Italian Color Field School, are also informed by aspects of Eastern philosophy, such as the dissolution of the ego, and by a long fascination with the color traditions of the Subcontinent.

Canadian photo-artist Edward Burtynsky confronts cultural interchange and interdependency in an entirely different manner, documenting the toll globalism has wrought on the environment where competition for scarce natural resources is increasing among nations. He lays bare industrial landscapes around the world—from China, to India, to Mexico—in vividly colored and detailed photographs. Similarly, photo-artist Sebestião Salgado has spent his distinguished career putting a human face on the phenomenon of globalism, photographing workers, human migration and indigenous peoples around the world whose lives have been irrevocably altered by the rapid pace of change and development. *Frontiers Reimagined* has a particularly strong photography component, reflecting the medium's newfound equality with painting.

*Frontiers Reimagined* was conceived in order to enlighten viewers about the conceptual and formal issues that emerge from intercultural exchange, which in the artistic sphere is increasingly the norm. It is our hope that viewers will recognize that this exchange is not only a present-day manifestation, but that it is very much the reality of the future.

In order for us to reap the positive benefits of globalization, we must accept and indeed celebrate that we are interdependent. By freely exchanging ideas and relying less on nationalism and regionalism and more on cooperation, acceptance and integration, we can prosper both materially and spiritually. Exploring cultural boundaries through art is one way to study and reflect upon the positive outcomes of globalization. At their best, the artists in this exhibition help us imagine a more harmonious existence.

The genesis of *Frontiers Reimagined* is rooted in my own multicultural origins. I grew up in post-colonial India in the 1960s and early '70s, where hybridity and confluence of cultures were pervasive. In addition, my family had been instrumental in fostering intercultural dialogue in the earlier part of the twentieth century through the establishment of a world university in Santiniketan, outside Calcutta. It

was a magnet for intellectuals from around the world and in 1922 it was host to the first traveling Bauhaus exhibition, with works by Paul Klee, Wassily Kandinsky and Lyonel Feininger. That led to the powerful, hybrid artistic forms that characterized the modern works of the Bengal School, as well as subsequent modern artistic movements on the Subcontinent, one of which my father, Subho Tagore, created in the 1940s. He borrowed freely from the Western canon to create an authentic Indian modernist visual language.

Having subsequently lived in Asia, North America and Europe, and having travelled extensively throughout the world for more than twenty-five years, it was only natural that intercultural dialogue should become my passion. I've been involved in promoting artists and curating exhibitions for the past eighteen years, and it is my goal to encourage a dialogue about cultural boundaries among artists, collectors, curators and the general public. I am privileged to be able to present these ideas in the wider atmosphere of the Biennale.

In the 1980s and '90s, one hardly encountered the contemporary art of India, China or Indonesia outside their borders except on rare occasions (*Magiciens de la terre* at the Centre Georges Pompidou in 1989 and *Contemporary Art in Asia: Traditions/Tensions* which opened in New York in 1996 are notable exceptions). And who could forget the late art historian Thomas McEvilley's brilliant critique of the 1984 *Primitivism* show at the Museum of Modern Art, in which he lambasted the museum and the art establishment for treating African, Asian and Oceanic art as little more than source material for Western artists. We've come a long way since that discourse. Today, the idea of borrowing or absorbing artistic source materials is not necessarily seen as a negative and non-Western art abounds. We need look no further than the 56th International Art Exhibition of the Biennale di Venezia, which has an African director, or Venice's own Peggy Guggenheim Collection, which will open an exhibition of the work of Vasudeo Gaitonde, one of India's great modernists, in late 2015.

Still, one must guard against overstating the ongoing dissolution of the art world's hegemonistic structures. As the critic Blake Gopnik pointed out very succinctly in a seminar on art and globalization held at the School of the Art Institute of Chicago in 2007, the contemporary art world functions like a chess game. The game can absorb unlimited players from across the globe. Those stronger, more variegated players may even enrich the game. As such, many extremely talented artists from non-Western countries who were precluded from this game in the '70s and the '80s are now easily accommodated. Particular or specific formalism, such as the Islamic script used by Shirin Neshat, or the African beer cap motifs of El Anatsui or the Indian tiffin forms of Subodh Gupta are accepted as general and global. These extra-European artists have added to the richness and complexity of the available artistic language by bringing in authentic forms from their own cultures.

These new artists are gaining space to sell their works and to express and present a voice that could not be heard before. They are well positioned to create a nuanced and a wider dialogue about the issues challenging us today. But Gopnik then reminds us that even though there are more players, the rules of the game have not changed. The rules are still made by Western institutions—museums, galleries, fairs, biennales, universities and the media—and followed by everyone. As long as the world models itself after systems structured by the West, we can't expect a new system to emerge.

Since the world we occupy is increasingly facing shared risks in politics, ecology and economics—which is to say in more or less all spheres of existence—art and artists who are amenable to taking risks and solving self-imposed problems are poised to be revelatory in this matter. I believe curatorial practices and exhibitions can act as a catalyst for change—ushering in the refurbishment of our society. Art and the artistic community are needed now to bind our disparate and discontented world together.

# New Pathways

**Marius Kwint**
Co-curator *Frontiers Reimagined*

*Frontiers Reimagined* explores what it means to be in a place, and to have a culture, in the age of globalization. In an era when rapid transport and instantaneous information technology girdle the planet, melting away terrestrial boundaries and facilitating the exchange of goods, cultures and peoples to a degree unprecedented in human history, how do artists around the world respond? The exhibition selects from the fruits of many years of research into this question by Sundaram Tagore, in an enterprise rooted in illustrious family history and sustained by an integrated ethical and aesthetic approach. I have been fortunate enough to share occasionally in this process, through conversation, observation and writing, since we were both graduate students at Magdalen College in the University of Oxford. To the somewhat antiquarian redoubt of Oxford art history in the late 1980s and early '90s, Tagore brought cosmopolitan art-world experience and curatorial know-how. He pursued a thesis about postcolonial artists who were shrugging off the most hegemonic and Eurocentric aspects of modernism and drawing more confidently (and viably) on regional or vernacular sources. Postmodernism was then being much debated, not always in the most sober terms, but within our first years of study, the fall of the Berlin Wall and the stirring of China seemed in part to fulfil the theory that, under "late" capitalism, social and cultural formations become more decentralized, fluid and horizontally organized.

Most of what has happened since has vindicated Tagore's position. As in so many other domains, globalization now determines the way in which visual art around the world is produced, consumed and discussed. We have seen the rise of international art fairs, many of them modelled on the Venice Biennale, alongside commercial galleries catering to a resilient and expanding global market in contemporary art. These developments have been most apparent in the metropolises of an industrializing Asia, but they are also well established in key cities in the Middle East, South America, and are emerging in an increasingly networked Africa. While the politics and grassroots social benefits of this transformation are disputed, there is no doubt that it has immeasurably expanded and enriched the polyglot global artistic conversation. Tagore has been at the forefront of the East-West currents in this dialogue, working with an extraordinarily diverse portfolio of artists who do not merely commoditise local cultures like souvenirs, but whose creative practice thrives in the mingling, melding and friction between cultures, even if the worldly scene is sometimes bleak. The artists in this exhibition therefore contribute to the imagining of alternative futures, which is the first and most difficult step towards their realization.

The visual arts are especially able to connect viewers instantly, intuitively, with the subjectivities of others of whom they know little, whose language they cannot read, and whose life-experiences they can only surmise. For example, the eminent Japanese artist Hiroshi Senju was awed by the *Ice Age* exhibition at the British Museum in 2013,

featuring artworks from up to 40,000 years ago. He felt a common bond with the artists of that far distant time and said that its people would still recognise the representation of falling water in his paintings. The waterfall motif is not, he says, so much an archetype from Zen Buddhism or traditional East Asian landscape painting, as a sign of our temperate planet earth, where the presence of liquid water permits life. "Personally, I feel the universe is one, with no boundaries," he says. "And in the age of the internet the world has changed dramatically. Where should I base my thoughts? What is the basis for thinking about the world? The definition of beauty has not changed; meaning has not changed." While the natural pigments he has used are testimony to the earth's ancient alchemy, the fluorescent paints and ultraviolet light that he newly employs in his installation for this exhibition are, he notes, the products of modern science, with which he believes art should be at one. They are, he jokes, normally associated with cheap signage rather than the fine arts, but to witness them in a darkened chamber, in a city already celebrated for aquatic and nocturnal spectacle, will, he hopes, be redolent of the most ancient and elemental of wonders.

Several of the artists in *Frontiers Reimagined* make work based in discrete locations: pertinent subjects when so few places are now beyond the reach and impact of the modern world. Mexican artist Ricardo Mazal seeks to convey his experience of spiritual heritage sites including the Mayan Tomb of the Red Queen in Palenque, Mexico, and Mount Kailash in Tibet, through an iterative process of abstraction, building up his paintings from photographic studies gathered *in situ* and digital manipulation. "Most of my projects begin with the place and my fascination for different cultures," he says. Mount Kailash, which features little in Western visual culture, forms the subject of his contribution to this exhibition. Situated at the source of four of Asia's greatest rivers, Kailash is sacred to the same number of religions (Buddhism, Hinduism, Bön and Jainism), who variously regard it as the hub of creation. Mazal's scraping of white paint resembles the striations of snow and ice that barely cling to the smooth black flanks of this magnificently remote and unclimbed Himalayan peak. In places, it also suggests the scales of the cobra that the commanding Hindu deity Shiva is said to wear about his neck as he resides there in eternal contemplation, and whose head the mountain embodies, particularly in the shape of the huge cornice poised over the north face. Wedges of orange, blue or red might represent prayer-flags fluttering in the rarefied breeze and sharp light of high Tibet. "Painting is part of a bigger puzzle," he says, speaking of the almost anthropological research he undertakes. "Sometimes I have a problem being categorized as just a painter. My work goes further than that." However, he adds, "painting still remains at the core of my expression. Combining digital photography and painting leaves you right on the edge between reality and abstraction."

The significance of mountains is highlighted by Hatian-Swiss artist Sasha Huber in her video installation *Rentyhorn*, though from a different context and intention. Huber is one of the few artists to have tackled the deep roots of racism in the history of science. Her intervention is part of an ongoing campaign and series of works to "demount" the celebrated Swiss naturalist, glaciologist and intellectual father of apartheid Louis Agassiz (1807–1873) from his commemoration by place-names around the world. Here she flies to the top of the mighty Agassizhorn in Switzerland to attempt to rename it "Rentyhorn" after the enslaved Congolese man Renty, whom Agassiz ordered to be photographed on a South Carolina plantation as an example of supposed racial inferiority. Huber's more recent work *Shooting Stars* continues the strain of activist restitution, by making commemorative portraits of the worldwide victims of politically or racially motivated shootings, including famous historical figures such as Martin Luther King and Mahatma Gandhi and the unarmed young black men recently gunned down by United States police. She creates these with a loud and aggressive-sounding staple gun on larch-wood, which she then covers in silver leaf, so that they almost resemble the Orthodox Christian icons that can be seen in many of the churches of her current home of Finland.

April Gornik's luminous, dreamlike, neo-Romantic landscapes and seascapes are not about real places or people, but invite seeming recognition without pinpointing, since they are at once somewhere and nearly anywhere, and show nothing man-made. They are, essentially, landscapes of the mind, while reminding us that nature knows no borders, and that even natural boundaries and shorelines are subject to continual erosion. "The ocean is anchoring and unravelling at the same time," she says; "it's all about coming apart." She cites Gaston Bachelard's famous book *The Poetics of Space* (1958), about the propensity of the imagination and memory infinitely to enlarge an image of immensity. She wants her viewers to have an immersive, strongly physical and emotional response informed by their own experience. She notes that several of them feel sure that they remember the places she apparently depicts, though the source-image might be from a different continent than where they claim to have been. Working from digitally manipulated photographs, Gornik says she knows when a painting is finished, because it seems "to recede and lock into place; there's no more entry point. The landscape is other."

For Nathan Slate Joseph, distinguished member of the New York School, memories of the landscape are important too, though expressed in more abstract forms. He collects shards of discarded steel, stains them with raw pigment and acid, and then weathers them so that their colors mellow and bloom with earthy tones, aggregations and textures. Often named after exotic-sounding locations, they strongly suggest an airborne view of layered patchworks of human habitation and cultivation. He was influenced by the Junk Art movement, including John Chamberlain and

Larry Rivers, after he moved to New York during the 1960s and '70s, when "it was very new and very free." Working with such scraps also reminds him of his Israeli youth, finding bits of military wreckage here and there: "I guess I just try to recycle personal history," he says.

The acclaimed Canadian photographic artist Robert Polidori takes the ruination and precariousness of civilization as his outward subjects, but sees himself principally "as a photographer of the psyche," rather than of buildings. "The labor of photography serves memory; it's a form of objective memory," he says. Citing Frances Yates's famous study of Renaissance mnemonic practice, *The Art of Memory* (1966), he tells of the Pythagoreans training their minds by memorising the contents of rooms. "I'm interested in traces of time superimposed on one another. People put in rooms what they think they are. I'm interested later in exteriors and the societal whole." Polidori acquires a keen sociological understanding of the places into which he takes his ultra-large-format camera and notes that most of the world's growing urban population lives in self-constructed cities on squatted land. "I'm a phenomenologist," Polidori says. "I'm trying to render meaningful documents—render them in a better aesthetic. I'll use any technological or ideological tool required to get the proper icon."

Some contributors dwell on the body, gender and sexuality, or the social and medical practices that prevail when humans are at their most abject, vulnerable or sensually aware. Texan artist Michael Petry, based in London, creates gorgeous, witty and subversive installations from traditional craft materials such as leather, glass, fabrics and pearls. They often combine coded references from gay men's subculture, transfiguring images sometimes taken from pornography with elevated spiritual and mythological themes, reminding the beholder of the paradox that the most unutterable beauty lays within our base physicality. Comparable insights are afforded by the late Punjabi-born Sohan Qadri's pigment-drenched paintings, which originate in his Tantric Buddhist practice, and may be regarded more as meditative starting-points or visualizations than expressive art in the Western sense. A more edgy encounter is provided by the work of Bangladeshi conceptual artist Tayeba Begum Lipi, who constructs glittering feminine underwear and other intimate household items such as a bed, pram and wheelchair from razor blades. The blades are standardized, but locally manufactured products that for her signify parturition within a large rural family, when an elder child was sent out to buy a new razor for the midwife to use; their steely glint also connotes widespread violence and discrimination meted out on the basis of gender and other fortuities of birth. "No-one wants to be local any more," she remarks. Korean painter-sculptor Chun Kwang Young probably speaks for many artists of his generation when he says that he tried Abstract Expressionism after immigrating to the United States in the 1970s, but never felt entirely happy with the style until doing something decisive to make it his own. In 1995, suddenly recalling the

memory of childhood visits to a traditional Chinese doctor, he began fashioning small mulberry-paper packages like the ones that he had seen hanging from the ceiling of the surgery, which served as both labels and wrappings for the mysterious medicines within. Chun assembles his versions of these little bundles of information and matter into large "aggregate" sculptures and paintings, suggesting strange, bristling viruses, cells or celestial bodies.

In the major calligraphic traditions of East Asia and the Middle East, art and the written word are unified through sacredness and embodied, performative memory. Islamic calligraphy in Arabic has given rise to several prominent artists who have loosened themselves from the strict rules governing their classical training and turned their skills to more abstract and pictorial expression. The Iraqi Hassan Massoudy (resident in Paris since the 1960s) is a widely acknowledged master of this genre. He monumentally expands single letters within quotations from ecumenical poets and philosophers from around the world, making their meanings visible by revealing his innermost feelings in response to the texts. Iranian painter Golnaz Fathi, who is one of the few women trained to the highest level in traditional Persian calligraphy, began to see her discipline with more pictorial eyes and wanted to communicate its ancient heritage with everyone—a desire that for many of her compatriots is frustrated by political and economic sanctions. She speaks warmly of her art as an almost ecstatic, dance-like process, of her love of music, Russian literature and the poetry of the German Margot Bickel (highly regarded in Iran), and her admiration for the modernist Chinese calligrapher Wang Dongling. Her creativity is spontaneous and corporeal: she likens it to giving birth, and has learned to recognise the feeling that the work is coming, so that picking up a brush or pen is the only way to still her mounting excitement. "The alphabets are my dancers," she says, although her exuberant, intricate paintings and drawings seldom contain legible scripts.

From the physicality and metaphysics of language, it is a short step to the matter of the mind, and question of how to represent our mental faculties, including the propensity for art. Dutch artist Fré Ilgen, living in Berlin, builds, among other things, sculptural models of neural connectivity in the brain in collaboration with neuroscientists, and researches questions about what such fast-developing biological insights mean for the practice and appreciation of art. Models of the relationship between mind, brain and body differ between cultures, but there are also important congruencies. In Nigeria, Osi Audu's upbringing introduced him to the Yoruba concept of the "inner head" (the realm of consciousness) versus the "outer head" (its physical substrate). Going to university in the regional capital Ife and then in Britain and the United States alerted him to the correspondence of these ideas with Western psychological and philosophical questions about how the brain, which is tangible, apparently produces the mind, which is not. Mental and

physical transport enabled him to re-evaluate and communicate a key element of his cultural background to audiences in Britain, Germany, the USA and Japan; he also contributed the entry on Yoruba concepts to *The Oxford Companion to the Mind* (2003). "Other cultures provide new tools for understanding and for giving your own culture resonance in the wider world," he observes. "The world is a mind. When we experience different cultures, new pathways are created in the brain. The world becomes a kind of collaboration with the neurological apparatus of the viewer." Now resident in New York, Audu views globalization as, on balance, a positive process arising from human communicative impulses, despite the history of injustice inflicted on Africa by the European imperial powers, many of whose infrastructures and institutions present-day globalization has inherited.

The intertwining histories of art and transcontinental commerce reach much further back than the age of high empire. Our venue, the splendid historic residence of the Grimani dynasty—pre-eminent merchants, politicians, scholars and patrons of the arts—is especially fitting in this light. Venetian painting of the sixteenth-century Golden Age was characterised by the lavish application of exotic pigments such as lapis lazuli from Afghanistan to large canvases, made from the fabric of ships' sails. Both kinds of material were relatively abundant in Venice, since the city was the maritime mercantile gateway between East and West. The colourful, expressive brushwork that Titian and his followers could thus afford brought new painterly possibilities to the medium. It might even be argued that by such means, Venetian painting took a step towards eventual Modernist abstraction, which served to undermine the European hierarchy between civilized (classical) and barbaric art.

Nevertheless, globalization has gathered pace exponentially since the end of Soviet communism and the triumph of neoliberal capitalism, enabled by microprocessors (which double in data capacity approximately every two years) and other technologies such as the gas turbine engine and shipping container. Many would see its current phase as no less problematic than its predecessors. Personal mobility and information technology for some have arguably come at the price of increasing inequality and insecurity for the majority, especially in the Global South, as further human and natural resources get plugged into multinational corporate grids for the extraction of profit. Longstanding social structures collapse as local economies are subjected to shock treatment, jobs are outsourced and vital public services are deregulated and privatized. Environmental degradation, colossal state surveillance and abusive repression, desperate migration and extreme ideological reactions have become increasingly evident over the past two decades.

World-renowned Brazilian photographer Sabastião Salgado depicts images of human forbearance and dignified suffering under such conditions, as well as more traditional lifestyles and kinds of labor seemingly untouched by modernity. It is possible to discuss, as some

have done, the ethics of portraying sometimes ugly realities in apparently beautiful ways, but to complain about this in Salgado's case would be ethically naive and overlook the full range and context of his work. Salgado certainly upholds the paramount value of dramatic and compelling imagery, brilliantly rendered in monumental, monochrome chiaroscuro. However, he makes a humanist and environmentalist virtue of the camera's talent for objectification, showing the earth and its inhabitants as a kind of wrinkled, continuous skin, whose surface beauty is indifferent to the fates of its diverse human and animal inhabitants as they nevertheless strive to uphold their innate dignity. He refuses to participate aesthetically in the degradation that might actually be occurring, and so affords the beholder not only hope but also the reason and moral resources to pursue it.

These artists, and several more of equal stature that I have not been able to mention, therefore do not merely reflect, but reimagine the frontiers between present and future. They are able to draw attention to shared common human assets and interests; and to create things that contain the seeds of further creativity. While appreciating the artistic achievements before us, it is perhaps appropriate to acknowledge the connection between their extraordinary capabilities and those shown by millions of migrant workers every day as they negotiate enormously complex patchworks of language, heritage and environment in order to make workable sense of their circumstances. They mostly do so out of necessity, but also out of hope.

*All quotations are from personal conversations between the author and the artists.*

**Works in the exhibition**

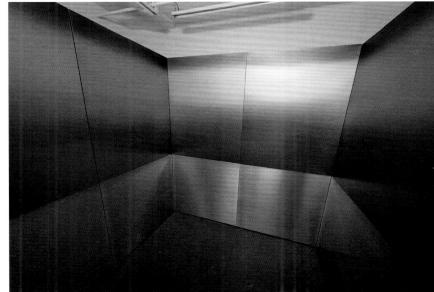

**Miya Ando**, *Shou-Sugi-Ban*, installation, 2015

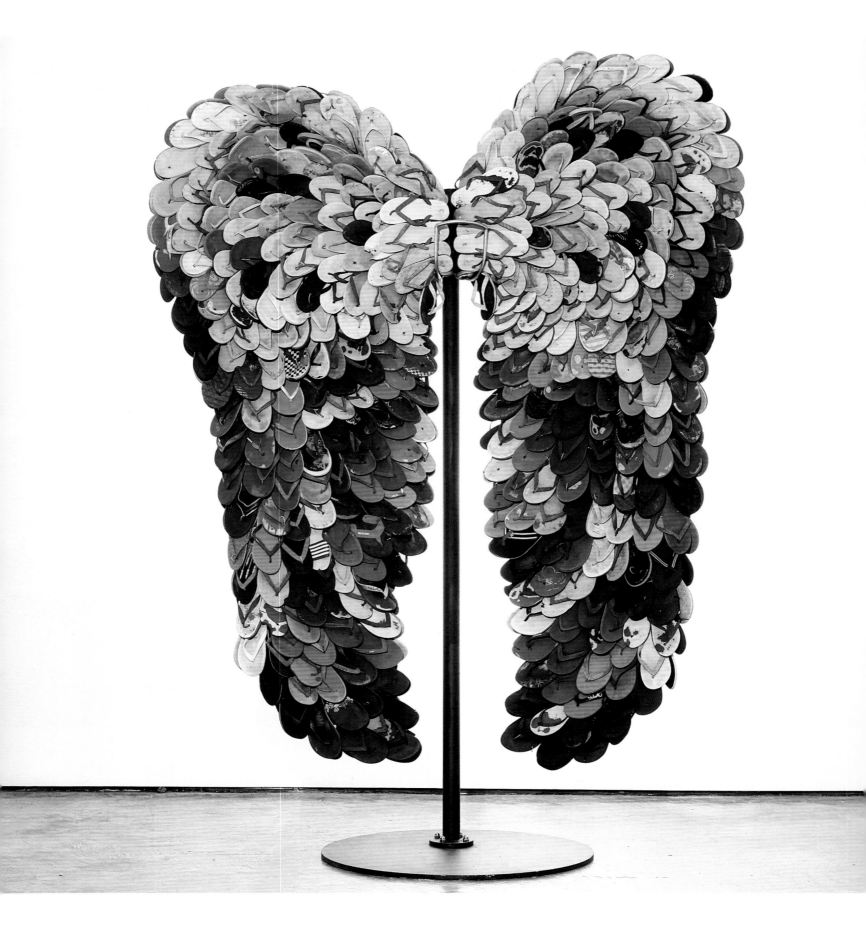

**Alfredo** and **Isabel Aquilizan,** *Wings III,* 2009

**Osi Audu**, *Self-Portrait II*, 2015

**Frances Barth**, *choc violet*, 2013; *IndRed towers*, 2013; *monitors*, 2013; *pink_o*, 2013; *red_white_yellow*, 2013; *running lines*, 2013

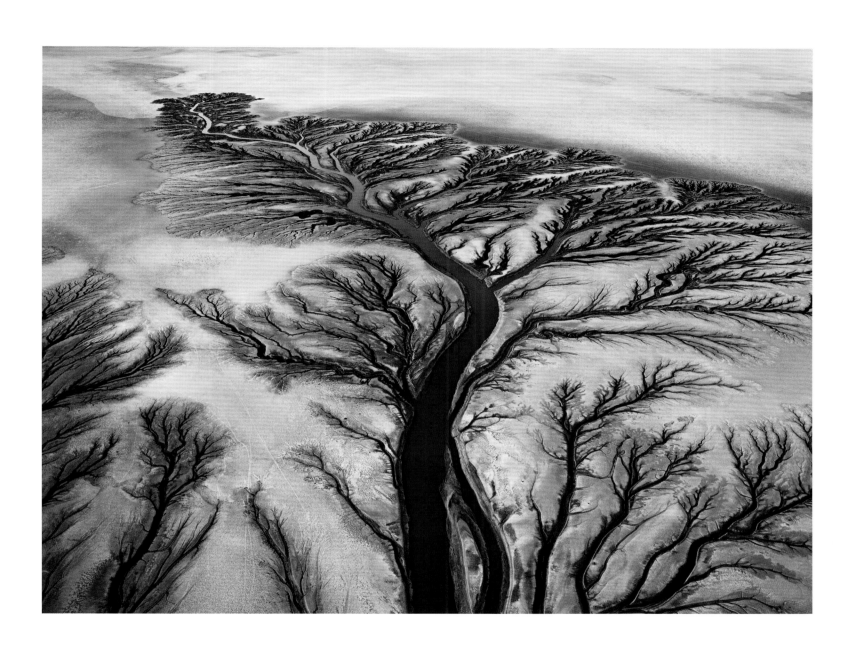

**Edward Burtynsky**, *Colorado River Delta #2*, 2011

Kamolpan Chotvichai, *Anicca*, 2014

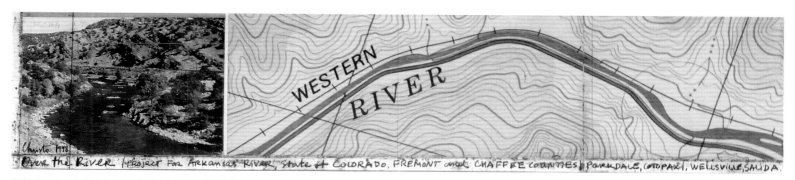

WESTERN RIVER

Christo 1998

Over the River (Project for Arkansas River, State of COLORADO, FREMONT and CHAFFEE COUNTIES) PARKDALE, COTOPAXI, WELLSVILLE, SALIDA.

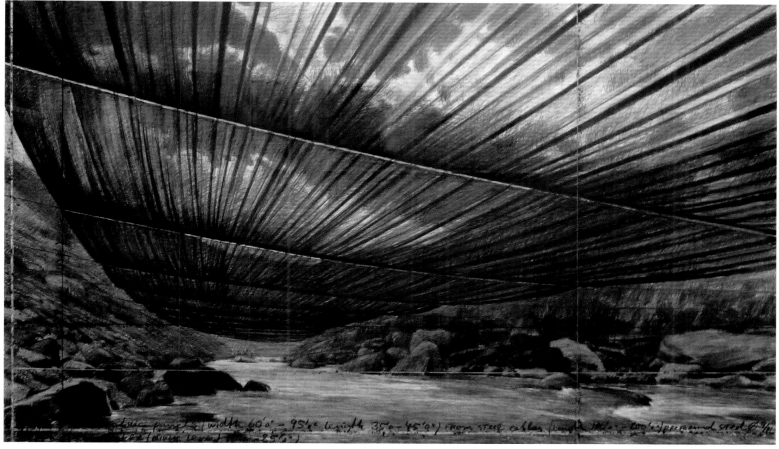

**Christo**, *Over the River, Project for the Arkansas River, Colorado, 1998*

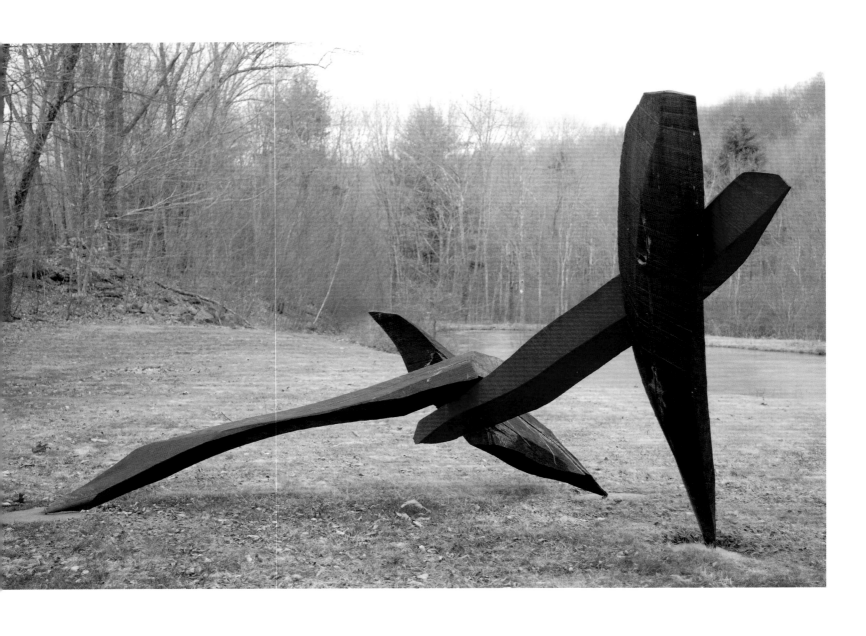

**Tom Doyle,** *Phoenix,* 1997

**Golnaz Fathi,** *Every Breaking Wave (1)*, 2014

**Olivia Fraser**, *I Am the Moon*, 2014

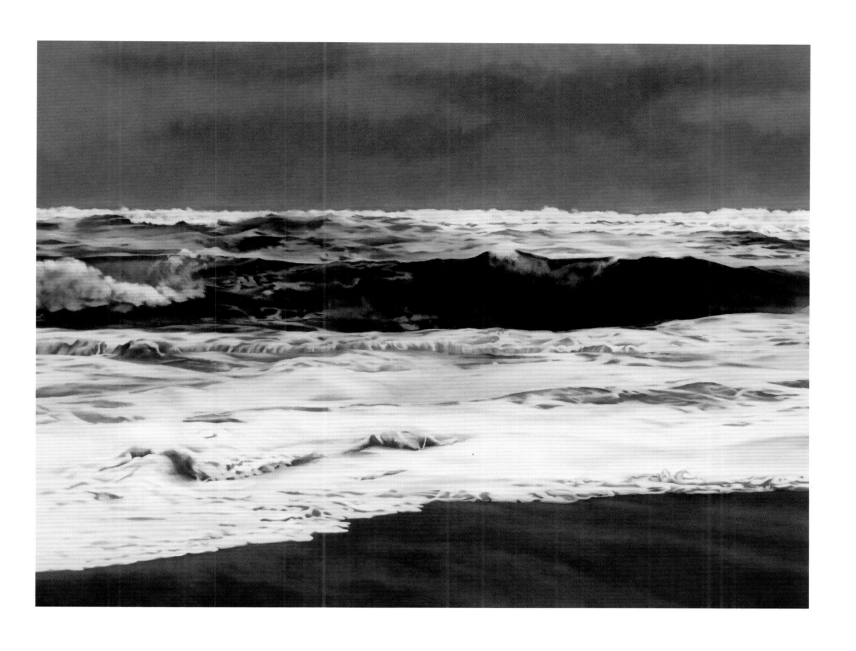

**April Gornik,** *Storm, Light, Ocean,* 2014

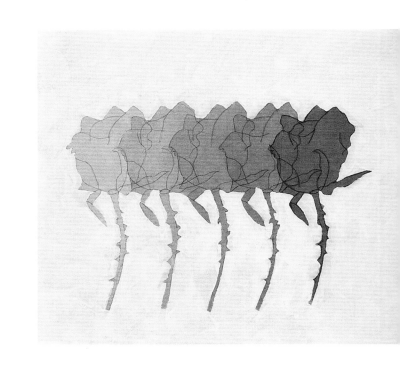

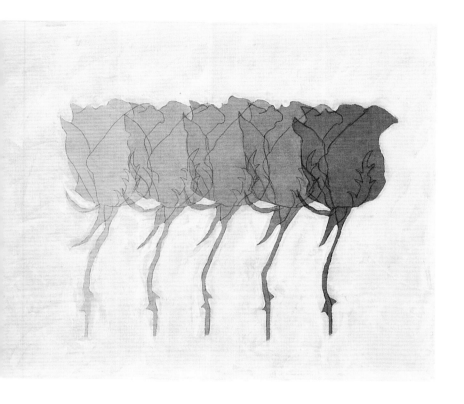
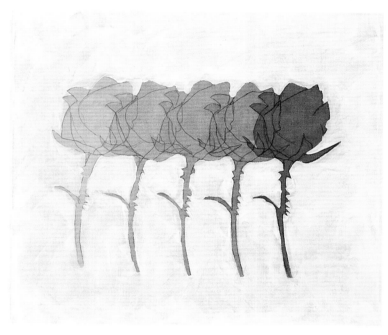

**Denise Green**, *A Rose Is a Rose Is a Rose... Rob*, 2014

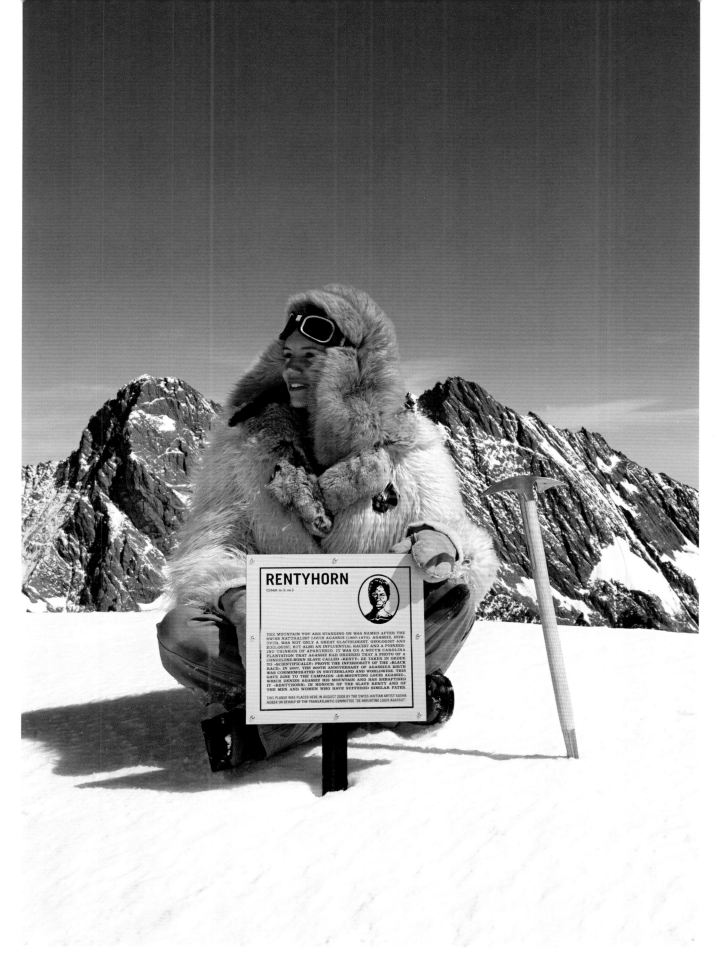

**Sasha Huber,** video still from *Rentyhorn – The Intervention*, 2008

**Georges Fikry Ibrahim,** *The Farmer*, 2006

**Fré Ilgen,** *Extension on One Chord,* 2007

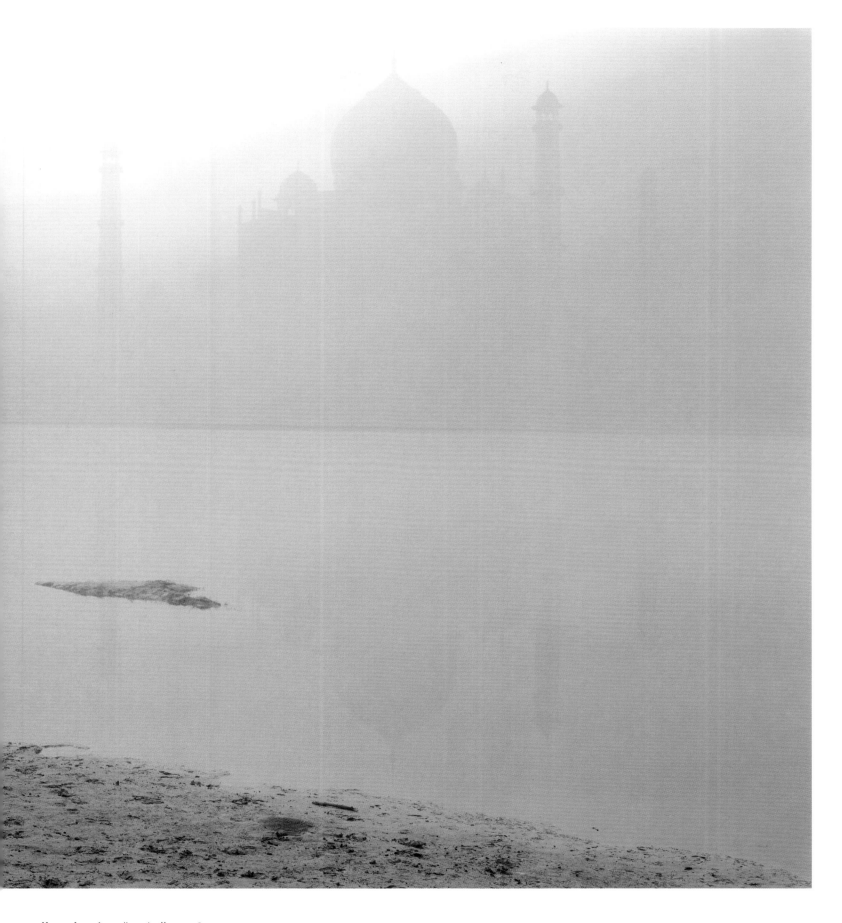

**Kenro Izu**, *Agra #43, India*, 2008

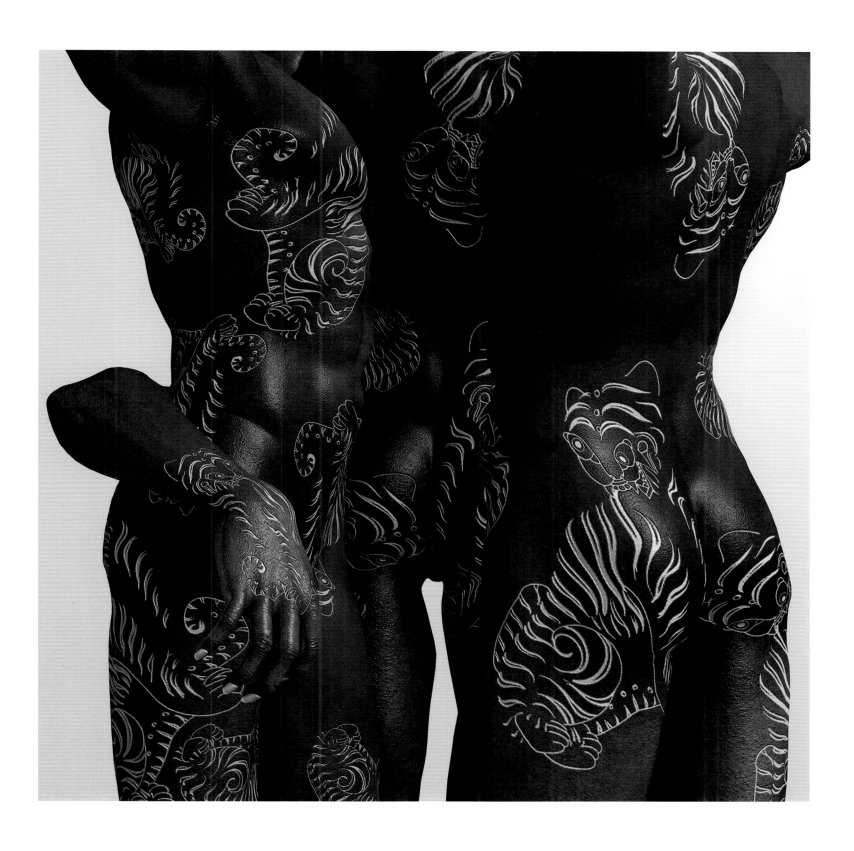

**Kim Joon,** *Ebony-Tiger,* 2013

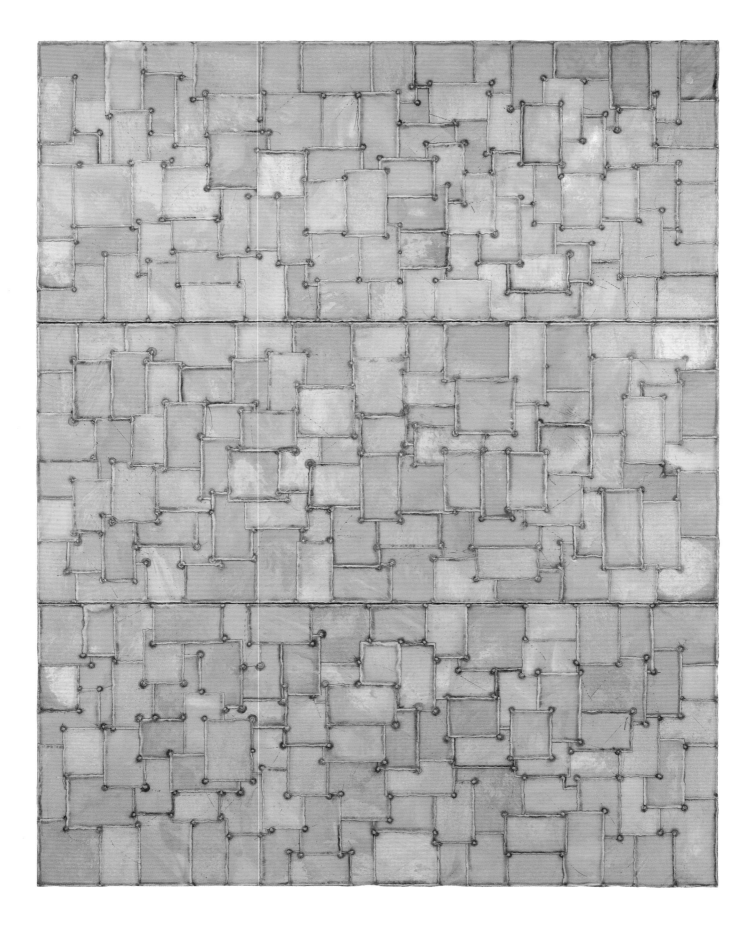

**Nathan Slate Joseph,** *Jerusalem We All Love You,* 2015

**Aaron Taylor Kuffner,** *Empat Bunga (4 Flowers)*, 2014

**Jane Lee,** *In You, In Me,* 2015

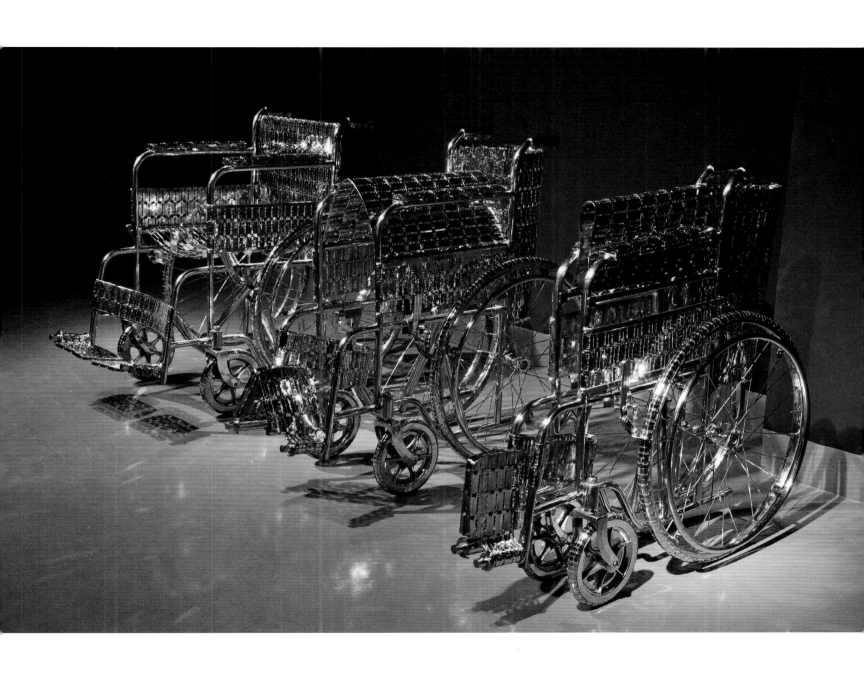

**Tayeba Begum Lipi**, *Agony*, 2015

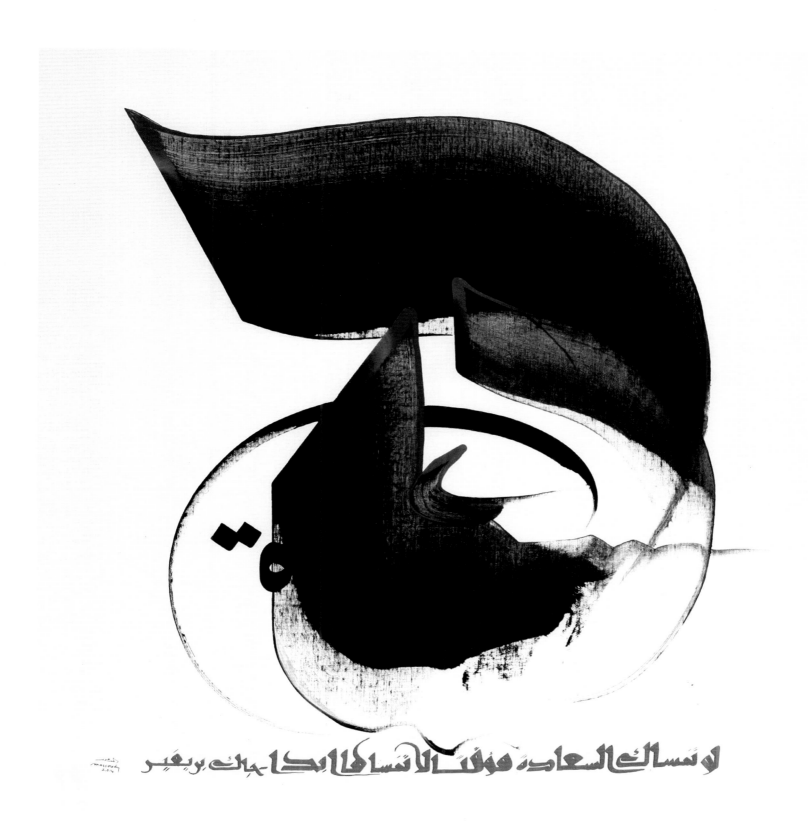

لو نسلك السعاده من قبل الانسان لما ادا جالك بريغير

**Hassan Massoudy,** untitled, 2014

68  **Vittorio Matino**, *At Pondichery*, 2008

**Ricardo Mazal,** *Black Mountain MK 2,* 2014

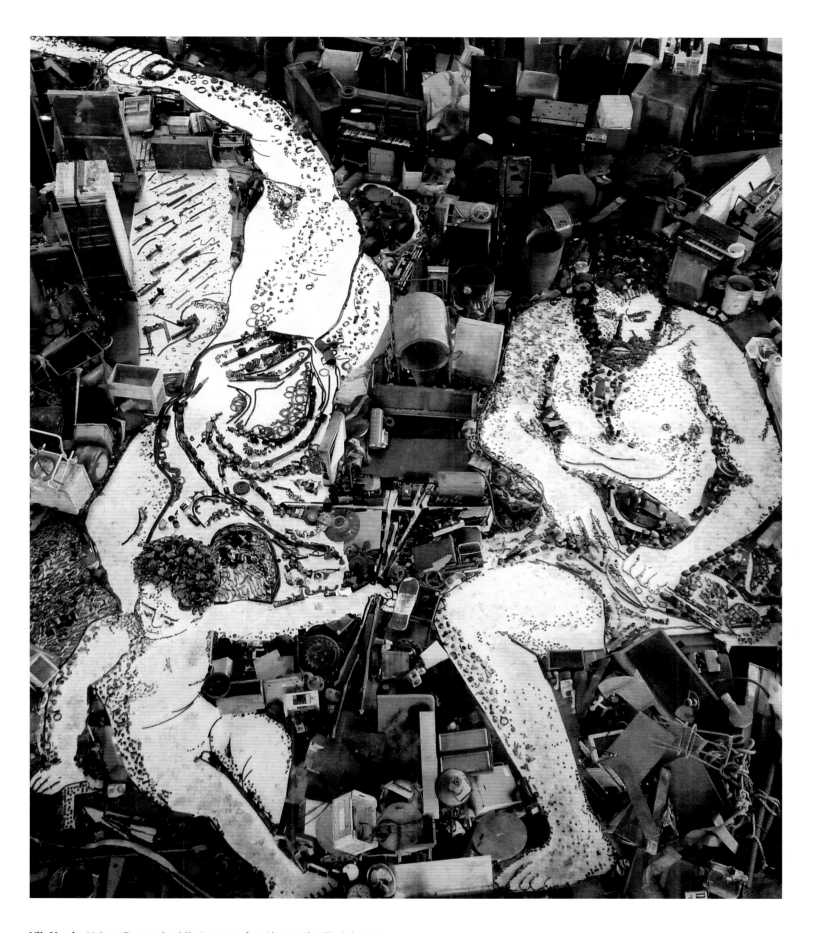

**Vik Muniz**, *Vulcan Forges Cupid's Arrows, after Alessandro Tiarini*, 2006

**Judith Murray**, *Oxygen*, 2014

**Michael Petry**, *Libation to Apollo*, installation, 2014

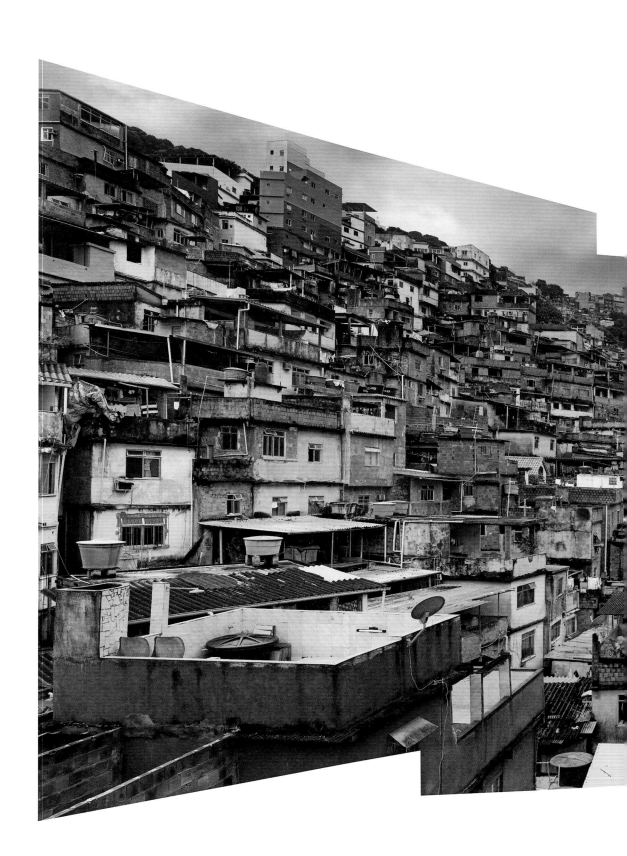

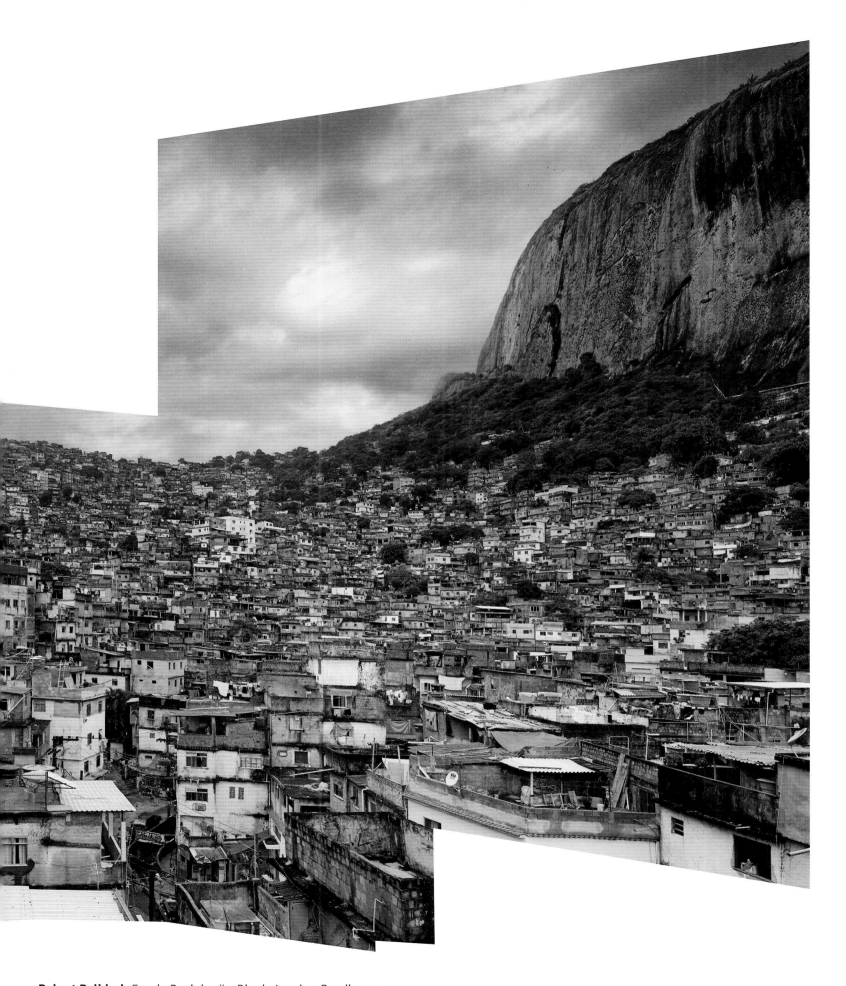

**Robert Polidori**, *Favela Rocinha #1, Rio de Janeiro, Brazil*, 2009

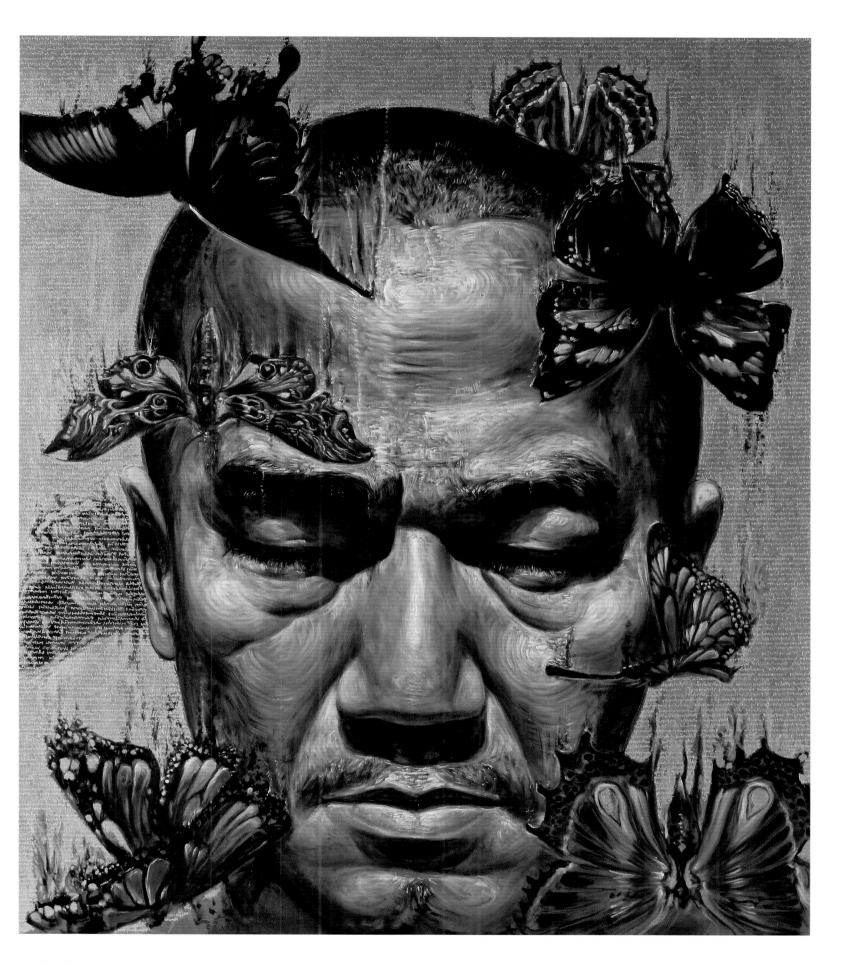

**Chatchai Puipia**, *Life in the City of Angels: War Zone*, 2014

**Sohan Qadri,** *Vijaya,* 2010

**Robert Rauschenberg,** *Giallo Call Glut (Neapolitan)*, 1987

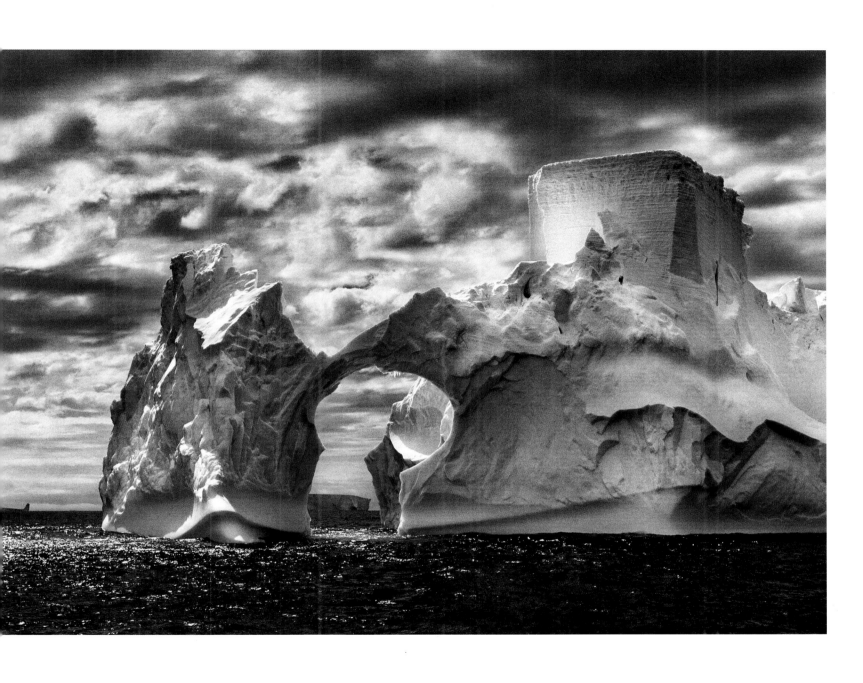

**Sebastião Salgado,** *Iceberg between Paulet Island and the South Shetland Islands in the Weddell Sea, Antarctic Peninsula,* 2005

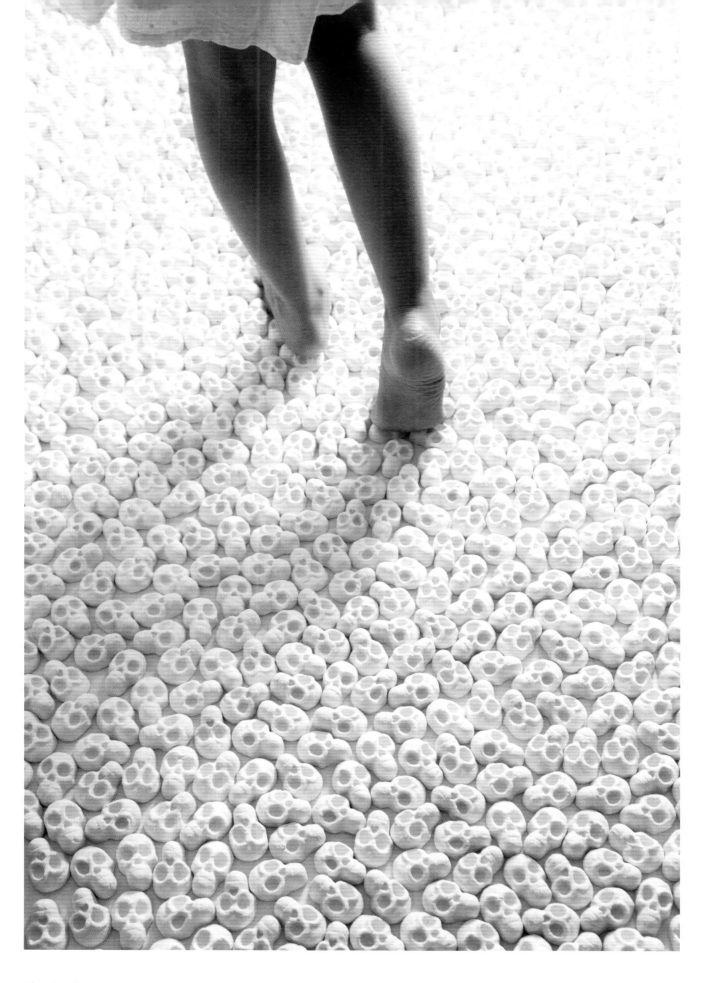

**Nino Sarabutra**, *What Will You Leave Behind?*, installation, 2012

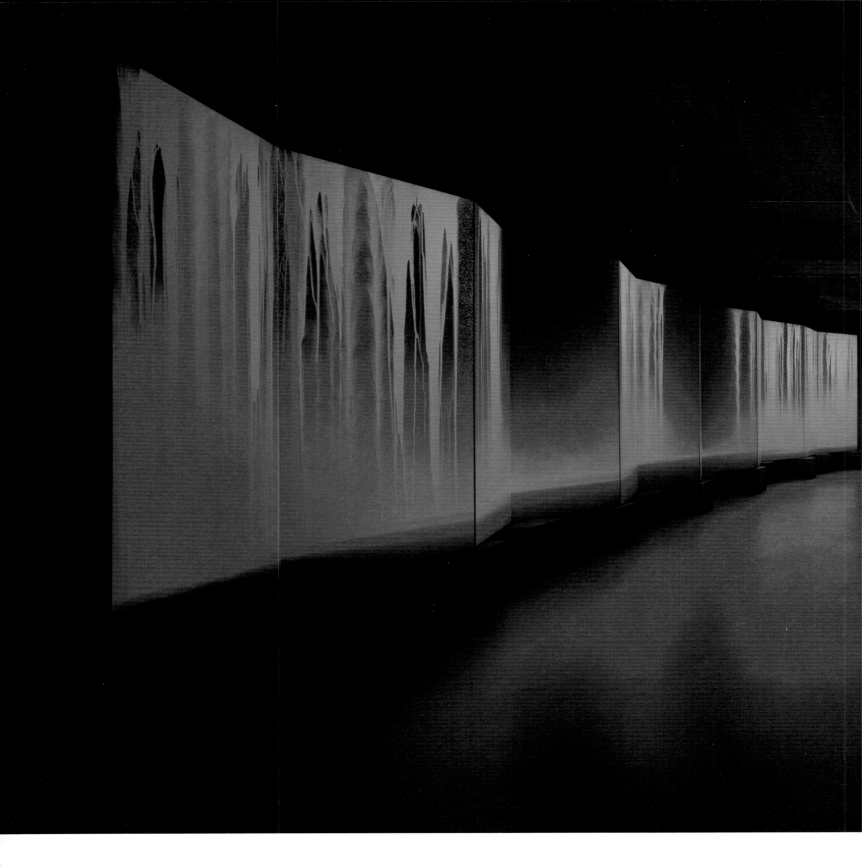

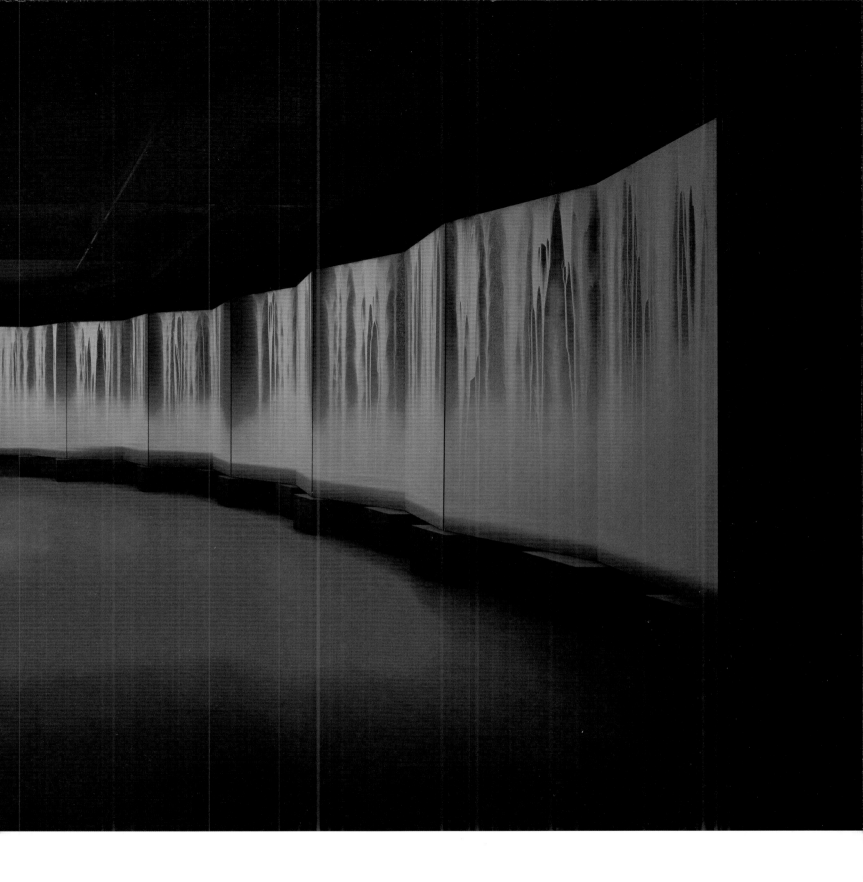

**Hiroshi Senju**, *Ryujin II* (installation, left), 2014; *Ryujin I* (installation, right), 2014

**Donald Sultan**, *Black and Whites Jan 20 2015*, 2015

**Jack Tworkov**, *Crossfield 1*, 1968

**Lee Waisler**, *Five in the World*, 2014

**Susan Weil**, *Body Shelley*, 2014

**Morgan Wong,** video still from *The Remnant of My Volition (Force Majeure)*, 2014

**Robert Yasuda,** *Element,* 2014

**Chun Kwang Young,** *Aggregation 8*, 2008

# Catalogue of works

The metal canvases and installations of artist **MIYA ANDO** articulate themes of contradiction and juxtaposition. The foundation of her practice is the transformation of surfaces. A descendant of Bizen swordsmiths she was raised among Buddhist priests in a temple in Okayama, Japan. Applying traditional techniques of her ancestry, she skillfully transforms sheets of aluminum and industrial steel, using heat and chemicals, into ephemeral abstractions suffused with subtle gradations of color. She says: "Metal simultaneously conveys strength and permanence and yet in the same instant can appear delicate, fragile, luminous, soft, ethereal. The medium becomes both a contradiction and juxtaposition for expressing notions of evanescence."

Miya Ando received a Bachelor of Arts degree in East Asian Studies from the University of California, Berkeley, and attended Yale University to study Buddhist iconography and imagery. She apprenticed with master metalsmith Hattori Studio in Japan, followed by a residency at Northern California's Public Art Academy in 2009. Ando is the recipient of many awards, including a Pollock-Krasner Foundation Grant in 2012.

Her work has been exhibited all over the world, including a show curated by Nat Trotman of the Solomon R. Guggenheim Museum. Miya Ando has produced numerous public commissions, most notably a thirty-foot-tall commemorative sculpture in London built from World Trade Center steel to mark the ten-year anniversary of 9/11.

**Born in Los Angeles, 1978**
**Lives and works in New York**

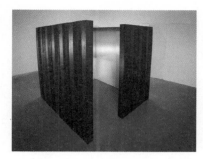

• *Shou-Sugi-Ban*, installation, 2015. Shou-sugi-ban façade, wood sub-structure, dyed aluminum panels, 7-foot cube/2.1-meter cube.

The husband-and-wife team of **ALFREDO** and **ISABEL AQUILIZAN**, who emigrated from the Philippines to Australia in 2006, addresses themes of displacement, change, memory and community. Their large-scale installations often reflect their own migratory experiences, while conveying points of exchange and communication that extend beyond borders.

The duo focuses on both individual narratives, as well as on relationships with the "other" in a new environment. The artists often collaborate with young people and migrants. For the 2009 Asia Pacific Triennial of Contemporary Art, the Aquilizans produced an enormous suspended sculpture titled *In-Flight (Project Another Country)*. The work comprised hundreds of tiny planes made by hand from found objects by children and adults during the course of the exhibition. *Project Be-Longing: In Transit*, 2006, which documents of the artists' emigration to Australia, consists of the family's personal effects arranged into neatly formed cubes. The sense of loss is apparent, as is the absence of actual containers, emphasizing the fragility of displacement.

The Aquilizans have shown their work at The Drawing Room, Manila; the 50th International Art Exhibition of la Biennale di Venezia, 2003; the 5th Gwangju Biennale, 2004; the 15th Biennale of Sydney, 2006; the Singapore Biennale 2008; the Liverpool Biennial 2010 held at Tate Liverpool; and the Sharjah Biennial 11, 2013.

**Alfredo Aquilizan, born in Cagayan Valley, Philippines, 1962**
**Isabel Aquilizan, born in Manila, 1965**
**Live and work in Brisbane**

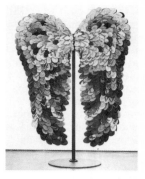

• *Wings III*, 2009. Used slippers and metal stand, 8.9 x 6.4 feet/ 2.7 x 2 meters.

• *Last Flight*, 2009. Used slippers and metal stand, 8.9 x 6.4 feet/ 2.7 x 2 meters.

With thanks to Cesar Villalon, The Drawing Room.

The work of Nigerian-born artist **OSI AUDU** focuses on the dualism of the tangible and intangible. His mediums are acrylic, graphite, pastel and wool on canvas or paper. Audu examines the scientific, philosophical and cultural concepts surrounding the nature of consciousness and the relationship between mind and body. Audu draws from his own experiences growing up in Nigeria and his work often alludes to the Yoruba people's concept that consciousness (referred to as "the head") has both a physical dimension ("the outer head") and a spiritual dimension ("the inner head"). Audu's work addresses the visual implications of these concepts.

Osi Audu received his undergraduate degree in fine arts from the University of Ife, Ife-Ife, Nigeria, and his master's degree at the University of Georgia in the United States. He has exhibited extensively, including at the Smithsonian National Museum of African Art, Washington, D.C.; the National Gallery of Modern Art and Franco-German Gallery, Lagos, Nigeria; Skoto Gallery and Bonhams, New York; Charlotte Street Gallery, the Africa Centre, the Science Museum and the British Museum, London; the Setagaya Art Museum and the Tobu Museum of Art, Tokyo. His work was also in the first Gwangju Biennale in 1995.

Osi Audu's works are in public and private collections around the world, including the Newark Museum, New Jersey; the Smithsonian National Museum of African Art; the Horniman Museum, the Wellcome Trust, the British Museum and the Nigeria High Commission, London; the Embassy of Switzerland in Nigeria and the National Gallery of Art, Lagos; SchmidtBank, Bayreuth, Germany; and the Addax and Oryx Group, Geneva.

**Born in Abraka, Nigeria, 1956**
**Lives and works in New York**

• *Self-Portrait II*, 2015. Pastel and graphite on Fabriano Artistico paper mounted on canvas, 56.5 x 76.5 inches/ 143.5 x 194.3 cm.

• *Self-Portrait V*, 2015. Pastel and graphite on Fabriano Artistico paper mounted on canvas, 56.5 x 76.5 inches/ 143.5 x 194.3 cm.

**FRANCES BARTH**'s imaginary landscape paintings are at once confounding and sublime. Radically abstract, they possess graphic clarity and are made of lush combinations of unnamable colors—saturated blue-grays, fiery orange-reds and pale yellow-greens—that don't exist in nature. She takes inspiration from traditional Chinese and Japanese landscape paintings, in which perspectives shift and which allow for vast panoramas within a compressed space.

Barth, who was a professor of painting, drawing and critical issues at Yale University from 1986 to 2004, incorporates modeling, animation, diagramming, symbol mapping and charting. Layering expanses of color with cartographical lines rendered with hand-made stencils and engineering drafting pencils, Barth creates multiple viewpoints; an aerial perspective one moment, and in another, intimate views of lengths of abstract color.

Her paintings are included in The Metropolitan Museum of Art, The Museum of Modern Art and the Whitney Museum of American Art, New York; and the Dallas Museum of Art. Her work is also in the private collections of JPMorgan and Chase and IBM Corporation, New York. She is the recipient of a John Simon Guggenheim Memorial Foundation Fellowship and two National Endowment for the Arts Grants. Barth was elected to the National Academy in 2011.

**Born in New York, 1946**
**Lives in North Bergen, New Jersey, and works in North Bergen and Baltimore, Maryland**

• *choc violet*, 2013. Acrylic on panel, 12 x 16 inches/30.5 x 40.6 cm.

• *IndRed towers*, 2013. Acrylic on panel, 12 x 16 inches/30.5 x 40.6 cm.

• *monitors*, 2013. Acrylic on panel, 12 x 16 inches/30.5 x 40.6 cm.

• *pink_0*, 2013. Acrylic on panel, 12 x 16 inches/30.5 x 40.6 cm.

• *red_white_yellow*, 2013. Acrylic on panel, 12 x 16 inches/30.5 x 40.6 cm.

• *running lines*, 2013. Acrylic on panel, 12 x 16 inches/30.5 x 40.6 cm.

Photographer **EDWARD BURTYNSKY** chronicles human impact on nature in his disarmingly beautiful images of industrial landscapes around the world. Burtynsky's painterly, often abstract photographs, frequently shot from an aerial perspective, show the massive scale of environmental devastation. Burtynsky began photographing nature in the early 1980s. His early works were intimate explorations of Canada's unspoiled landscapes. By the late 1980s, however, he turned away from the quickly disappearing natural terrain, realizing that this was the world that we were losing not the one we were to inherit. Instead, he began to investigate industrial incursions into land with arresting results.

Edward Burtynsky was recognized with a TED Prize in 2005. In 2006 he was named an Officer of the Order of Canada, one of the nation's highest civilian honors. He holds six honorary doctorate degrees and his distinctions include the National Magazine Award, the MOCCA Award, the Outreach Award at the Rencontres d'Arles and the Applied Arts Magazine Complete Book Photography Award. In 2006, Edward Burtynsky was the subject of the award-winning documentary *Manufactured Landscapes*, which screened at the Sundance Film Festival. His newest film, *Watermark*, debuted in 2013.

Edward Burtynsky's works are in the collections of more than fifty museums worldwide, including the Solomon R. Guggenheim Museum and The Museum of Modern Art, New York; the Albright-Knox Art Gallery, Buffalo, New York; the Bibliothèque nationale, Paris; The Photographer's Gallery and the Victoria and Albert Museum, London; Museo Nacional Centro de Arte Reina Sofía, Madrid; and the National Gallery of Canada, Ottawa.
**Born in St. Catharines, Ontario, Canada, 1955**
**Lives and works in Toronto**

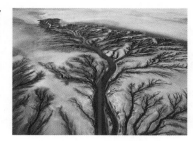

• *Colorado River Delta #2*, 2011. Chromogenic color print, 60 x 80 inches/152.4 x 203.2 cm.

**KAMOLPAN CHOTVICHAI** addresses issues of identity and gender in her photo-based self-portraits. At the same time, she challenges the formal limitations of paper and canvas by meticulously hand-cutting her images, creating sinuous ribbons along various parts of her anatomy. Her goal is to dissolve her form, based on the Buddha's teachings on *anatta*, which refers to the eternal substance that exists beyond the physical self.

The artist received a Master of Fine Arts degree at Silpakorn University, Bangkok, and has since been awarded numerous scholarships and art prizes, including a Gold Medal at the 58th National Exhibition of Art, Bangkok, 2012.

Chotvichai was invited to participate in ON PAPER, a paper art workshop that was part of the exhibition *ON PAPER 2013 Paper and Nature* at Tama Art University Museum, Tokyo. Recent solo exhibitions include *Emptiness* at the Ardel Gallery of Modern Art, Bangkok, 2013. Group exhibitions include *Anthropos Bangkok*, Numthong Gallery, Bangkok, 2013; *Anthropos: Navigating Human Depth in Thai and Singapore Contemporary Art* at Sundaram Tagore Gallery in Singapore and New York, 2013; the *4th Young Artists Talent Art Exhibition 2013*, Royal Thai Consulate-General, Los Angeles; and the *2012 International Women Arts Exhibition, Lights of Women*, Gwangju Museum of Art Kum Namro Wing, Metro Gallery, Korea.
**Born in Bangkok, 1986**
**Lives and works in Bangkok**

• *Anicca*, 2014. C-print and hand-cut canvas, 39.8 x 42.9 inches/101.1 x 109 cm.

• *Anatta*, 2014. C-print and hand-cut canvas, 39.8 x 42.9 inches/101.1 x 109 cm.

• *Dukkha*, 2014. C-print and hand-cut canvas, 45 x 39.8 inches/114.3 x 101.1 cm.

**CHRISTO** is best known for his collaborative environmental art projects, most notably, his large-scale site-specific installations in which he wrapped buildings, monuments and vast spans of nature in fabric.

A Bulgarian refugee who arrived in Paris in 1958, he began making small wrapped works—books, cans and furniture—with the intention of allowing everyday objects to take on new identities. In the mid-1960s, the artist and his wife, Jeanne-Claude, moved to New York and began to conceptualize more ambitious projects. Over the years they collaborated on numerous temporary large-scale installations devised to alter a structure or a space, thus granting the viewer a unique opportunity to perceive a familiar environment with new eyes and a new consciousness. While their projects were often met with resistance from municipal officials and environmentalists, ultimately they became huge communal events attended by millions of people the world over.

Christo and Jeanne-Claude's large-scale public projects include *Wrapped Coast, Australia, 1968–1969*; *Valley Curtain, Rifle, Colorado, 1970–1972*; *Running Fence, Sonoma and Marin counties, California, 1972–1976*; *Surrounded Islands, Biscayne Bay, Florida, 1980–1983*; *The Pont Neuf Wrapped, Paris, 1975–1985*; *The Umbrellas, Japan–USA, 1984–1991*; *Wrapped Reichstag, Berlin, 1971–1995*; *Wrapped Trees, Riehen, Switzerland, 1997–1998*; and *The Gates, Central Park, New York, 1979–2005*.

**Born in Gabrovo, Bulgaria, 1935**
**Lives and works in New York**

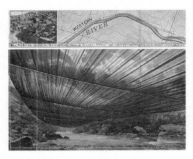

• *Over the River, Project for the Arkansas River, Colorado, 1998*. Pencil, charcoal, pastel, wax crayon, topographic map in two parts: 15 x 65 inches and 42 x 65 inches/ 38.1 x 165.1 cm and 106.6 x 165.1 cm.

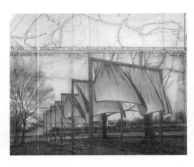

• *The Gates, Project for Central Park, New York City, 2002*. Pencil, charcoal, pastel, wax crayon on paper in two parts: 15 x 65 inches and 42 x 65 inches/ 38.1 x 165.1 cm and 106.6 x 165.1 cm.

With thanks to Frank Cassou and Gabrielle Cassou.

The thrust of American sculptor **TOM DOYLE**'s work—both figuratively and physically—is the desire to suspend forms in space, sustained by just three supports. Although his works range in size from eight inches to fifteen feet, they share the same principle of lift, as if buoyed by the artist's struggle to achieve weightlessness, or even flight. Doyle was formatively influenced by Abstract Expressionism, particularly Franz Kline, and the artists of diverse European backgrounds that contributed to it. Many of his works express lyrical themes through his use of rough wood and stone with place-name titles that speak of his ancestral Ireland — a nostalgia for the land often shared by diaspora cultures with histories of displacement.

Tom Doyle is the recipient of a John Simon Guggenheim Memorial Foundation Fellowship, 1982; a National Endowment for the Arts Fellowship Award in Sculpture, 1990–1991; an American Academy of Arts and Letters Jimmy Ernst Award in Art, 1994; and was elected a member of the National Academy in 1997. In 2014 he received the Art Purchase Program for Sculpture Award from the American Academy of Arts and Letters.

His works are installed at the New Britain Museum of American Art, Connecticut; Queens College, New York; Congregation Beth Shalom Rodfe Zedek, Chester, Connecticut; and the Jean Widmark Memorial, Roxbury, Connecticut.

**Born in Jerry City, Ohio, 1928**
**Lives and works in Roxbury, Connecticut**

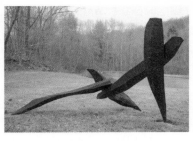

• *Phoenix*, 1997. Bronze (from oak and cherry), 5.8 feet high x 10 feet wide x 7.5 feet long/ 1.7 meters high x 3 meters wide x 2.2 meters long.

Drawing on her extensive training as a calligrapher, **GOLNAZ FATHI** uses texts and letters as formal elements, transforming traditional calligraphy into a personal artistic language. She studied classical calligraphy before she established her own style of working, receiving a Bachelor of Arts in Graphics from Azad Art University, Tehran, and completing further studies at the Iranian Society of Calligraphy.

Fathi works in fine pen, mostly on varnished raw, rectangular, polyptych canvases, in a limited palette of white, black, red and yellow. She layers the surface of the canvas with thousands of minute marks that echo the curvilinear forms of calligraphic letters and words. These intricate lines coalesce into minimalist compositions that can be read in multiple ways—as landscapes, electronic transmissions or atmospheric phenomena.

The basis of Fathi's practice is *siah-mashq*, a traditional exercise in which the calligrapher writes cursive letters across the page in a dense, semi-abstract formation. The letters aren't meant to form words or convey meaning, but rather strengthen the skill of the scribe. Fathi reinterprets this technique, drawing inspiration from Western and Eastern sources, including American Abstract Expressionism, as well as the work of Iranian and Middle Eastern modernists who pioneered the use of the written word as a pictorial element in the late 1950s and early 1960s. By skillfully combining these various elements, she has created a unique visual language with universal appeal.

Golnaz Fathi's works are in the permanent collections of The Metropolitan Museum of Art, New York; Brighton & Hove Museum, East Sussex, England; Carnegie Mellon University, Doha, Qatar; the Islamic Arts Museum Malaysia, Kuala Lumpur; the Asian Civilisations Museum, Singapore; the British Museum, London; the Devi Art Foundation, New Delhi; and The Farjam Collection, Dubai. In 2011, Fathi was chosen as a Young Global Leader Honoree by the World Economic Forum.

**Born in Tehran, 1972**
**Lives and works in Tehran and Paris**

• *Every Breaking Wave (1)*, 2014. Acrylic and pen on canvas, 3.7 x 11.1 feet/ 1.1 x 3.4 meters.

Born in London, brought up in the Highlands of Scotland, **OLIVIA FRASER** has lived and worked in India since 1989. She combines the techniques, vocabulary, mineral and plant pigments, and handmade paper (*wasli*) of traditional Indian miniatures with forms and ideas from modern Western art, including the archetypal shapes, colors and rhythms explored in the works of Kazimir Malevich and the Suprematists as well as in the Op Art of Bridget Riley and Sol LeWitt. Her experience as an immigrant physically entering the Indian landscape is reflected in her use of landscape as a starting point in many of her works, which feature highly stylized natural elements in rhythmic patterns.

Olivia Fraser graduated with a Master's Degree in Modern Language from the University of Oxford and spent a year at Wimbeldon Art College before settling in India. Since then she has studied traditional Indian miniature painting techniques under Jaipuri and Delhi masters. She follows in the footsteps of her ancestor, James Baillie Fraser, who painted India, its monuments and landscape in the early 1800s.

The artist's work is included in public and private collections in Australia, France, India, Singapore, the United Arab Emirates, the United States, the United Kingdom and the Museum of Sacred Art, Septon, Belgium. Her work has been shown in solo exhibitions in India, China and the United Kingdom. Her work was recently on view in *Forms of Devotion: The Spiritual in Indian Art* at Lalit Kala Galleries, Rabindra Bhavan, in New Delhi, an exhibition organized by Lalit Kala Akademi (National Academy of Art) India and the Museum of Sacred Art, Belgium and Italy.

**Born in London, 1965**
**Lives and works in New Delhi**

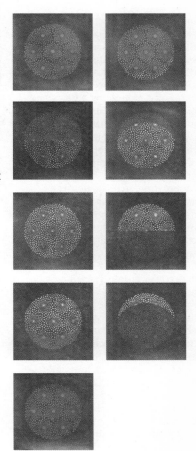

• *I Am the Moon*, 2014. Stone pigment, gold leaf and gum arabic on handmade Sanganer paper, nine panels, each 14 x 14 inches/35.6 x 35.6 cm.

An influential member the New York art scene since the late 1970s, **APRIL GORNIK** is known for her powerfully evocative large-scale landscapes. Highly atmospheric and charged with energy, Gornik's depopulated scenes of oceans, mountains, forests and prairies—all under luminous skies—are not copies of nature. Unlike painters of the nineteenth-century Hudson River School, to which she is often compared, Gornik uses photography, rather than direct observation, to help create her imagery. She selects elements from different photographs, manipulating them digitally and forming a collage or composite of a landscape as she sees it.

Although she works in a genre some may consider retrograde or nostalgic, Gornik is a modern painter whose work is rooted in observed reality and a world synthesized, abstracted, stored and remembered. Gornik's work compels the viewer to explore the tension between quietude and the unstoppable momentum of atmospheric change. April Gornik trained at the Nova Scotia College of Art and Design, Canada. Her work is included in the collections of The Metropolitan Museum of Art, the Whitney Museum of American Art and The Museum of Modern Art, New York; the National Museum of American Art and the National Museum of Women in the Arts, Washington, D.C. From August 2004 to February 2005, Gornik was honored with an exhibition at the Neuberger Museum of Art, Purchase, New York. Gornik's work was also included in the 1999 Whitney Biennial and in 1984 was in the American Pavilion at the 41st International Art Exhibition of la Biennale di Venezia.
**Born in Cleveland, Ohio, 1953**
**Lives and works in New York**

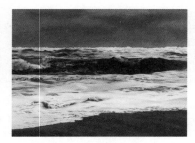

• *Storm, Light, Ocean*, 2014. Oil on linen, 6.5 x 8.7 feet/2 x 2.7 meters.

With thanks to Danese/Corey.

**DENISE GREEN** combines Indian and Aboriginal philosophy with modernist technique, composing deeply personal works.
Disembodied objects such as roses, fans and stone fragments hover in the center of her mixed-media paintings and works on paper. These objects are not meant to be read literally. They are extensions of the artist's inner world, alluding to her experiences with loss and grief. Green has been studying the concept of metonymy, which she describes as the fusion of the inner, spiritual and outer material world, as it is posited by Aboriginal culture in her native Australia.
She trained at New York's Hunter College in the 1970s, where she received a Master of Fine Arts degree. She studied under Mark Rothko and Robert Motherwell and the influence of her teachers is evident in her use of color fields filled with recurrent motifs. Before that, she studied for a Baccalaureate at École des Beaux-arts at Université de Paris-Sorbonne in the 1960s.
Denise Green's work is in The Museum of Modern Art and the Solomon R. Guggenheim Museum, New York; the Albertina Museum, Vienna; and the National Gallery of Australia, Canberra.
Green first received public recognition through her participation in the *Young American Artists: 1978 Exxon National Exhibition* at the Solomon R. Guggenheim Museum and the *New Image Painting* show at the Whitney Museum of American Art in 1979. Since then her work has been exhibited in more than one hundred fifteen solo shows in the United States, Europe and Australia. In 2000, a retrospective of her work was launched at MoMA PS1 in New York and toured ten museums, including the Art Gallery of New South Wales, Sydney, and the Museum Kurhaus Kleve, Germany. Green is the author of *Metonymy in Contemporary Art: A New Paradigm*, 2005, and *An Artist's Odyssey*, 2012, both published by the University of Minnesota Press and Macmillan Art Publishing in Australia. She was awarded the Order of Australia in 2007.
**Born in Melbourne, 1946**
**Lives and works in New York**

• *A Rose Is a Rose Is a Rose... Rob*, 2014. Pencil, acrylic and modeling paste on linen, three panels 2.7 x 8.9 feet/ 0.82 x 2.7 meters overall.

**SASHA HUBER** employs a variety of media, including painting, installation, video, photography and performance. Huber's early training was as a designer, but her focus shifted to fine art as she began to examine the relationship between her aesthetic practice and her cultural identity.

Early on, the focus of Huber's work was the exploration of her Haitian heritage viewed through the lens of colonial history, but over time her practice has grown to include a broader range of post-colonial realities—although Haiti is still a reoccurring theme in her work. Huber has critiqued imperialism with portraits of Christopher Columbus and various Haitian dictators made from staples shot into pieces of driftwood. She has drawn attention to the effects of institutionalized racism by spearheading a project with historian and political activist Hans Fässler, in which they advocated by means of protest and petition, renaming the Swiss Mountain Agassizhorn, named for racial theorist Louis Agassiz, after an enslaved Congolese man named Renty. Huber documented her efforts on video and in photographs and drawings.

Sasha Huber has exhibited extensively around the world, including at the 19th Biennale of Sydney, 2014; in *Haiti: Two centuries of artistic creation* at the Grand Palais, Paris, in 2014 and 2015; El Laboratorio Arte Alameda, Mexico City; New Shelter Plan, Copenhagen; the Center of Contemporary Art, Tbilisi, Georgia; the Hasselblad Foundation, Gothenburg and the Botkyrka Konsthall, Tumba, Sweden; Retretti Art Centre, Punkaharju, Kunsthalle Helsinki and the Kiasma Museum of Contemporary Art, Helsinki; and Riga Art Space, Latvia.
**Born in Zurich, 1975**
**Lives and works in Helsinki**

• video stills from *Rentyhorn – The Intervention*, 2008. 4 minutes, 30 seconds.

With thanks to Frame Visual Art Finland.

**GEORGES FIKRY IBRAHIM**, a professor in the faculty of art education at Helwan University, Cairo, has developed a special technique for using collage in his large-scale works. Layers of paper are placed on a support, painted and often decorated in gold leaf. He renders figures and articles from the world of objects in abstract style. Egyptian culture and its roots are his major theme. Ancient writing including hieroglyphs are among the cultural and philosophical symbols he uses to show the way of life in Egyptian society. He also uses elements of sacred architecture and art, such as pyramids, temples, the royal pharaohs, tombs, old Coptic monasteries, Islamic architecture, folkloric elements and narrations. Georges Fikry Ibrahim has shown his work in numerous solo and group exhibitions, including Kunstmuseum Bonn; El Arousa, Ahmed Shawki Museum, Cairo; the 52nd International Art Exhibition of la Biennale di Venezia, 2007; The American University in Cairo; Zamalek Arts Complex, Cairo; the International Cairo Biennale; and the Egyptian Cultural Office Center in Rome.
**Born in Cairo, 1963**
**Lives and works in Cairo**

• *The Farmer*, 2006. Mixed media on paper, 11.2 x 7.8 feet/3.4 x 2.4 meters.

**FRÉ ILGEN**'s sculptures and mobiles depict a reality that is not a solid mass but a swirling movement of shifting relationships. This emphasis on movement or "gravity defied" is an expression of Ilgen's reverence for change and a desire to challenge the viewer's visual memory. Ilgen also explores Eastern ideas of enlightenment or *sunyata* and the Western mathematical theories of quantum physics. His sculptures are constructed of painted wood and stainless steel, varying in size from modest to monumental. In each piece, there is a simulation of spiraling forces, reminiscent of the energies of the chakras as well as the double helix of human DNA. Ilgen is not only a sculptor and a painter, but also a theorist and curator. His work is exhibited widely in the United States, Europe, South America, Russia, Asia and Australia. He has created many site-specific pieces for private, corporate and public collections in the Netherlands, Germany, Switzerland, Japan, Korea and the United States. Ilgen's work is in the collections of the Museum Modern Art, Hünfeld, Germany; NOKIA, Dallas, Texas; and the Merzbacher Collection, Zug, Switzerland. In 2011 Ilgen curated *Mirrors of Continuous Change*, a large exhibition of global art, in Seoul.

His publications include *Fré Ilgen: The Search*, a retrospective, 2001; followed by *Art? No Thing! Analogies between Art, Science and Philosophy*, 2004 and *Artist? The Hypothesis of Bodiness*, 2014.
**Born in Winterswijk, Netherlands, 1956**
**Lives and works in Berlin**

• *Extension on One Chord*, 2007. Stainless steel, wood, industrial paint, 89.75 x 65.4 x 23.25 inches/ 228 x 166.1 x 59.1 cm.

One of the greatest living platinum printers, photographer **KENRO IZU** uses a custom-built, three-hundred-pound Deardorff camera to produce deeply compelling images of revered religious monuments in Syria, Jordan, England, Chile and most recently, Buddhist and Hindu monuments in Cambodia, Burma, Indonesia, Vietnam and India.
Izu began working as a commercial photographer in New York shortly after emigrating from Japan in 1970. After visiting some of the sacred sites of Egypt, Izu was struck by the dichotomy between the massive stone structures and a sense of impermanence. Izu began to shift his focus to fine art photography, travelling to some of the most remote areas of the world to capture sacred sites and worshippers.
Kenro Izu's work has been featured in solo exhibitions around the world, including at the Rubin Museum of Art, New York; the Fitchburg Museum of Art, Massachusetts; the Peabody Essex Museum, Salem, Massachusetts; and the Detroit Institute of Art, Michigan.
Izu is the recipient of numerous honors, including the Lucca Photo Award from the Photo Lux Festival, Italy; the Vision Award from The Center for Photography, Woodstock; a National Endowment for the Arts Grant and a John Simon Guggenheim Memorial Foundation Fellowship. His work is in the collections of the Smithsonian Institution's Arthur M. Sackler Gallery, Washington, D.C.; the Museum of Fine Arts, Boston; the Canadian Centre for Architecture, Montreal; the J. Paul Getty Museum, Los Angeles; the Museum of Fine Arts, Houston; The Metropolitan Museum of Art, New York; the San Francisco Museum of Modern Art; Tokyo Metropolitan Museum of Photography; and Galleria Civica di Modena.
**Born in Osaka, Japan, 1949**
**Lives and works in Rhinebeck, New York**

• *Agra #43, India*, 2008. Archival pigment print, 44 x 60 inches/ 111.8 x 152.4 cm, edition A.P. 1

• *Do Chu La #129, Bhutan*, 2003. Archival pigment print, 44 x 60 inches/ 111.8 x 152.4 cm, edition 2/3.

**KIM JOON** creates digital prints focusing on themes of desire, memory and fragility. He uses the human body as his canvas, superimposing tattoos and exotic animal skins on hyperrealistic flesh. He fabricates elaborate tableaux using the computer software 3ds Max, in which he juxtaposes these "skinned" nudes, symbols of Western pop culture and luxury-brand logos, deftly celebrating and questioning mass culture.

Kim Joon's works have been exhibited at the Saatchi Gallery, London, where his work was featured on the cover of *Korean Eye: Contemporary Korean Art*, the book that accompanied the exhibition of the same name; Total Museum of Contemporary Art, Seoul; The National Museum of Modern and Contemporary Art, Gwacheon, Korea; and the National Taiwan Museum.

**Born in Seoul, 1966**
**Lives and works in Seoul**

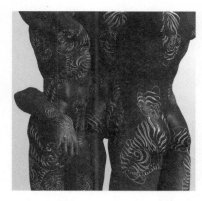

• *Ebony-Tiger*, 2013. Digital print, 47 x 47 inches/119.4 x 119.4 cm, edition 1/5.

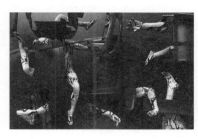

• *Crush 02*, 2014. Digital print, 46.8 x 74.9 inches/120 x 192 cm, edition 1/5.

**NATHAN SLATE JOSEPH** has been an integral member of the New York School of Art for more than forty years. He blurs the boundary between painting and sculpture, creating dimensional works made of shards of discarded steel. He stains the metal with raw pigments and acids, then exposes them to the elements outside his studio. During this process, the metal acquires rich, saturated color and varied textures. He cuts the steel plates then layers and assembles them using spot-welding to produce intricate, three-dimensional arrangements. Much like contemporaries Frank Stella, Carl Andre and John Chamberlain, Joseph began his career by experimenting with scrap metal and other found objects. A journey to Mexico in the 1970s inspired a shift toward his dramatic color palette. By incorporating color into his work, Joseph extended the language of the junk art movement. Travels through China, India and Indonesia, where he encountered shantytown dwellers crushing cans and scavenging for materials to make shelters, led to a desire to merge urban aesthetics with a concern for nature.

Nathan Slate Joseph was awarded an Institute Honor Award for Architecture from the American Institute of Architects in 2002 and has collaborated on numerous large-scale public projects with the renowned designer Adam D. Tihany. His paintings have been acquired by the Zimmerli Art Museum, New Brunswick, New Jersey; and Art in Embassies, Washington, D.C., for United States embassies in Cyprus, Mexico and Turkey. Private collectors include artist John Chamberlain, singer-songwriter Joni Mitchell and chef Jean-Georges Vongerichten.

**Born in Rishon LeZion, Israel, 1943**
**Lives and works in New York**

• *Jerusalem We All Love You*, 2015. Pure pigment on steel, 10 x 7.8 feet/ 3 x 2.4 meters.

**AARON TAYLOR KUFFNER** creates site-specific sound installations comprising an orchestra of handcrafted percussion instruments derived from the traditional Balinese gamelan and robotic technology. Kuffner, who is deeply immersed in Balinese culture, both preserves and reinterprets traditional gamelan music.

Kuffner studied at the Institut Seni Indonesia Yogyakarta and lived in the village of Sewon, Bantul, Indonesia. There he embraced the traditions of both the gamelan and village life. After returning to the United States he was granted an artist-in-residency with the League of Electronic Musical Urban Robots in Brooklyn, New York, where he developed the concept of merging robotic technology and Balinese percussion instruments. Kuffner's works have been installed worldwide, including two exhibitions in New York curated by Alanna Heiss, founder and former director of MoMA PS1. He has received grants and sponsorship from The Andy Warhol Foundation for the Visual Arts and the Trust for Mutual Understanding, New York; the Mid Atlantic Arts Foundation, Baltimore, Maryland; and the Ministry of Foreign Affairs, Jakarta.

**Born in New York, 1975**
**Lives and works in New York**

• *Empat Bunga (4 Flowers)*, 2014. Patinated steel, bronze Balinese gongs, dragon turtle cymbals, robotic mallets:
Canvas A: 76.4 x 52 x 19.7 inches/ 194 x 132 x 50 cm.
Cavas B: 72 x 48.9 x 19.7 inches/ 183 x 124 x 50 cm.
Canvas C: 68.5 x 70 x 19.7 inches/ 174 x 178 x 50 cm.
Canvas D: 72 x 70 x 19.7 inches/ 183 x 178 x 50 cm.

• *Kebangkitan: The Red Birds*, 2015. Bronze Balinese gongs, robotic mallets and powder coated steel:
Part 1: 3.1 x 9.3 x 1.1 feet/ 0.9 x 2.8 x 0.3 meters.
Part 2: 2.2 x 9.3 x 1.1 feet/ 0.7 x 2.8 x 0.3 meters.

**JANE LEE** is best known for her inventive techniques and innovative use of materials. She explores the very nature of the way paintings are constructed by treating the components of a painting— stretcher, canvas, and the paint itself—in new ways. In the process, she is re-examining the significance of painting and the relevance of contemporary art practice.

The surfaces of her paintings are highly tactile and sensuous, often dimensional enough to be considered sculptures. In some cases, Lee dispenses with canvas altogether extruding acrylic paint directly on wooden stretchers, which results in a hollow, three-dimensional object, with the paint at the bottom seemingly giving in to the force of gravity. The paintings are mounted on the wall, the floor and in the corners of rooms. With this strategy of activating the spaces in which her works are being presented, she uses space itself as a medium.

Jane Lee has won numerous awards, including a Celeste Prize for painting in 2011. She was a finalist for the 2007 Sovereign Asian Art Prize and was the first recipient of the Singapore Art Exhibition International Residency Prize in 2007. Her work *Raw Canvas* was showcased at the Singapore Biennale 2008, *Collectors' Stage* at the Singapore Art Museum in 2011 and in the *Southeast Asia Platform*, a curated exhibition of cutting-edge work organized by region, at Art Stage Singapore in 2014. In 2015, her work was selected for *Prudential Singapore Eye*, one of the largest surveys of Singapore's contemporary art to date, held at the ArtScience Museum and *Medium at Large, a* year-long exhibition at the Singapore Art Museum.

Jane Lee has a Bachelor of Fine Arts and a Diploma in Fashion from LASALLE College of the Arts in Singapore. She has participated in numerous exhibitions in museums and galleries in Asia and Europe, among them the Hong Kong Arts Centre and the Contemporary Art Centre in Vilnius, Lithuania.

**Born in Singapore, 1963**
**Lives and works in Singapore**

• *In You, In Me*, 2015. Acrylic paint, acrylic paste, pigment, epoxy, reflective mirror on wood, 7.2 x 10.7 x 0.7 feet/ 2.2  x 3.3 x 0.21 meters.

**TAYEBA BEGUM LIPI** creates paintings, prints, installations and videos articulating themes of female marginality and the female body. Lipi produces sculptural works re-creating everyday objects including beds, bathtubs, strollers, wheelchairs, dressing tables and women's undergarments using unexpected materials, such as safety pins and razor blades. This purposeful and provocative choice of materials speaks to the violence facing women in Bangladesh, as well as references tools used in childbirth in the more undeveloped parts of the country.

In 2002 Lipi co-founded the Britto Arts Trust, Bangladesh's first artist-run alternative arts platform dedicated to organizing exhibitions, encouraging intercultural dialogue and providing residencies for local artists.

Tayeba Begum Lipi completed a Master of Fine Arts in Drawing and Painting at the Faculty of Fine Arts, University of Dhaka, in 1993. In 2000 she was an artist-in-residence at the Irish Museum of Modern Art, Dublin. She was awarded a Grand Prize at the 11th Asian Art Biennale Bangladesh 2003, Dhaka; was commissioner for the Pavilion of Bangladesh at the 54th International Art Exhibition of la Biennale di Venezia, 2011; and one of the curators for the Kathmandu International Arts Festival 2012. Lipi has exhibited at Alliance Française, Paris and the Bengal Gallery of Fine Arts, Dhaka. She also participated in the 14th Jakarta Biennale 2011, the Colombo Art Biennale 2012, Sri Lanka, and Dhaka Art Summit 2012.
**Born in Gaibandha, Bangladesh, 1969**
**Lives and works in Dhaka**

• *Agony*, 2015. Stainless-steel razor blades and stainless steel:
a. 40.9 x 26 x 36.2 inches/ 104 x 66 x 92 cm.
b. 42.1 x 20 x 36.2 inches/ 107 x 51 x 92 cm.
c. 43.3 x 11 x 36.2 inches/ 110 x 28 x 92 cm.

• *My Mother's Dressing Table*, 2013. Stainless-steel razor blades, 37.5 x 18.5 x 39 inches/95.3 x 47 x 99.1 cm, edition 3/3.

With thanks to Yesim Turanli, Pi Artworks.

Classically trained calligrapher **HASSAN MASSOUDY** inscribes oversized letters in vibrant colors on paper to create visually compelling works that bring traditional Arabic script into a contemporary context. Massoudy sources words from Eastern and Western authors, poets and philosophers. He selects a passage, which he writes at the bottom of a sheet of paper, then extracts a single word, enlarging it to monumental proportions over the entire surface of the paper. In accordance with tradition, Massoudy makes his own tools and inks, but breaks from the Arabic custom of using black ink by incorporating a bold palette of blues, greens, yellows and reds. Although executed with the utmost control, his letters are gestural, fluid and charged with energy, as he skillfully transforms the written word into a pictorial element. Massoudy studied classical calligraphy in Baghdad. He moved to France in 1969, continuing his education at the École Nationale Supérieure des Beaux-Arts in Paris. He has shown his work at The Kennedy Center, Washington, D.C.; the British Museum, London; Musée d'Avranches, France; Centre d'Art Contemporain, Abbaye de Trizay and the Palais des Congrès de Grasse, France. His work is in the collections of The British Museum, London; Asian Civilisations Museum, Singapore; and Musée du Quai Branly, Paris. He has also shown at Sharjah Biennale 11, 2013.
**Born in Najaf, Iraq, 1944**
**Lives and works in Paris**

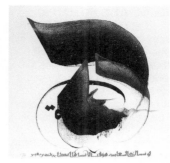

• untitled, 2014. Acrylic on canvas, 41.6 x 40.6 x 1 inches/103 x 103 x 3 cm.

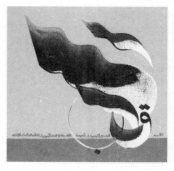

• untitled, 2014. Acrylic on canvas, 41.6 x 40.6 x 1 inches/103 x 103 x 3 cm.

Italian artist **VITTORIO MATINO** has produced vibrantly colored abstract paintings for the past forty years. His exceptional use of luminous color, which radiates from the canvas as pure energy and his wide chromatic scale are informed by his investigations of the Venetian School while living in the Veneto region of Italy during his formative years. The discovery of foreign cultures has been a pressing necessity and has helped liberate him from the weight of Italy's long and rich artistic tradition. The thrust—and the challenge—of Matino's practice is the dissolution of cultural boundaries. He has traveled extensively, studying Asian and African art and deepening his connection to American Action Painting and Color Field abstraction. His formal investigations, though firmly rooted in the Italian Color Field School, are also informed by aspects of Eastern philosophy, such as the dissolution of the ego, and by a long fascination with the color traditions of the Subcontinent. Neither expressionistic nor purely geometric in approach, his formal framework is distinctly his own. Not only has Matino extended the language of the Italian Color Field School but he has also expanded our understanding of color. Matino has exhibited extensively throughout Italy, in Rome, Milan, Naples, Bologna, Venice, Verona, Vicenza and Padoua. He has had solo and group exhibitions throughout Europe, North America and Australia, including Paris and Nice; Zürich and Locarno; Krefeld, Frankfurt am Main and Bonn; Vienna; London; New York; Montreal; and Sydney. Matino has had solo exhibitions in numerous museums and public spaces, including Museo Civico, Palazzo Chiericati, Vicenza; Padiglione d'Arte Contemporanea, Milan; Galleria Civica, Villa Valle, Valdagno; Palazzo Pretorio, Cittadella; and Museo Civico di Brunico, Italy.

In 1997, Matino created a 14-meter mosaic for the Bologna metro station in Rome as part of the Art Metro Roma project. His work is in the collections of major Italian museums and corporations, including Museo del Novecento, Intesa Sanpaolo Galleria d'Italia, the Prada Foundation and Edison, Milan; and Enimont, New York.

**Born in Tirana, Albania, 1943**
**Lives and works in Milan**

• *At Pondichery*, 2008. Acrylic on linen, 7.9 x 8.6 feet/2.4 x 2.6 meters.

• *Beyond Blu Two*, 2012. Acrylic on linen, 7.9 x 10.7 feet/2.4 x 3.3 meters.

• *Impossibile Blu*, 2009. Acrylic on linen, 7.9 x 8.6 feet/2.4 x 2.6 meters.

**RICARDO MAZAL** explores themes of life, death, transformation and regeneration through a multidisciplinary approach to painting that includes photography and digital technology.

In 2004, the artist embarked on a trilogy examining the sacred burial rituals of three cultures, continents and time periods. He began at the Mayan tomb of the Red Queen in Palenque, Chiapas, Mexico, then traveled to the FriedWald forest cemetery in Odenwald, Germany. His latest series—inspired by the sky burials of Mount Kailash, Tibet's holiest summit—marks the final installment of his triumvirate.

In each of his investigations, photographs have been the impetus. For Mazal, photography is a bridge that links reality to abstraction. He begins by manipulating his photographs on the computer to compose a digital sketch. He then moves onto the canvas, delicately layering oil paint using foam-rubber blades. To reveal luminous passages of color, Mazal sweeps a dry blade with varying degrees of pressure across the canvas. The vestiges of paint are almost embryonic in structure with faint texture and hue.

Ricardo Mazal's work is included in the collections of the Scottsdale Museum of Contemporary Art, Arizona; Museo de Arte Moderno, Mexico City; Museo de Arte Abstracto Manuel Felguérez, Zacatecas, Mexico; Maeght Foundation, Saint-Paul-de-Vence, France; and Deutsche Bank, New York and Germany. In 2006, a retrospective of his work was held at the Museo de Arte Moderno, Mexico City. In 2015, the artist will have a second solo show at Mexico City's Centro Cultural Estación Indianilla.

**Born in Mexico City, 1950**
**Lives and works in Santa Fe, New Mexico and New York**

• *Black Mountain MK 2*, 2014. Oil on linen, 90 x 96 inches/ 228.6 x 243.8 cm.

The mixed-media works of **VIK MUNIZ** are composed from found objects—food, dirt, garbage—then repurposed and configured into intricately layered re-creations of canonical and historical artworks which are then photographed for the final piece.

In 2008, Muniz began a project in Brazil photographing *catadores* (trash-pickers) and reconfigured the images into iconic paintings, such as Jacques-Louis David's *The Death of Marat*. He then re-created the photographs in large-scale arrangements made from bits of trash. The three-year endeavor was documented in the film *Waste Land*, which was nominated for an Academy Award in 2011.

In recognition of his commitment to social change and raising awareness about poverty, Muniz was named a UNESCO Goodwill Ambassador. Vik Muniz's work is included in numerous collections, including the Centro per l'Arte Contemporanea Luigi Pecci, Prato, Italy; The International Center of Photography, The Metropolitan Museum of Art, the Solomon R. Guggenheim Museum, The Museum of Modern Art, the Brooklyn Museum and the New Museum, New York; The Museum of Contemporary Art and the J. Paul Getty Museum, Los Angeles; Musée d'art contemporain de Montréal; MUSAC, Museo de Arte Contemporáneo de Castilla y León, Spain; the Tate Gallery and the Victoria and Albert Museum, London; Museu de Arte Moderna de São Paulo; the Irish Museum of Modern Art, Dublin; Israel Museum, Jerusalem; Museum of Contemporary Art Tokyo and Nichido Contemporary Art, Tokyo; La Maison Européenne de la Photographie and Fondation Cartier pour l'art contemporain, Paris. In 2001, Muniz represented Brazil at the 49th International Art Exhibition of la Biennale di Venezia
**Born in São Paulo, 1961**
**Lives and works in New York**
**and Rio de Janeiro**

• *Vulcan Forges Cupid's Arrows, after Alessandro Tiarini*, 2006. Chromogenic print, 50 x 44 inches/ 127 x 111.8 cm, edition A.P. 2/4.

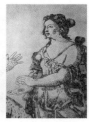

• *Apollo and the Cumaean Sibyl, after Giovanni Domenico Cerrini*, 2007. Chromogenic print, 62 x 44 inches/ 157.5 x 111.8 cm each (diptych), edition 4/6.

With thanks to Frank Cassou.

**JUDITH MURRAY**, who works primarily in oil on canvas, has created a trademark language that is abstract and deeply expressive, with short, animated brushstrokes chasing each other in lively patterns across the surfaces of her paintings. She uses a palette of only four base colors: red, yellow, black and white. The varied hues in the hundreds of works she has produced—paintings, drawings, prints and sculpture—have emerged from just this palette. Murray, who has traveled extensively, from the jungles of South America to the ancient temples of Asia, researching crafts and art, believes it represents her primary, universal palette, with reference to prehistoric painting and aboriginal art around the world. Compositionally, Murray works from an off-square format and all her paintings include a vertical bar along the right edge. By their very nature and design, the paintings remain abstract as the bar prevents any completion of pictorial space. Judith Murray has had solo shows at the Clocktower and MoMA PS1, New York; the Dallas Museum of Fine Arts; as well as numerous gallery exhibitions including at the historic Betty Parsons Gallery in 1976. She is the recipient of the American Academy of Arts and Letters Academy Award in Painting; a John Simon Guggenheim Memorial Foundation Fellowship; and a National Endowment for the Arts Award. Murray was inducted into the National Academy, New York, in 2009.

Judith Murray's work is in the collection of the Consulate General of the United States, Mumbai; the royal family of Abu Dhabi; the Library of Congress, Washington, D.C.; the Brooklyn Museum and the New York Public Library; and Honolulu Museum of Art.
**Born in New York, 1941**
**Lives and works in New York**
**and Sugarloaf Key, Florida**

• *Oxygen*, 2014. Oil on linen, 8.3 x 4.5 feet/2.5 x 1.4 meters.

Artist, writer and curator **MICHAEL PETRY**'s visual work focuses on installation art practice—a kind of art that rejects concentration on one object in favor of a consideration of the relationship between things and their contexts. The medium has a broad parentage that extends from Marcel Duchamp's readymades, through the 1960s incarnations of Edward Kienholz, Claes Oldenburg, Allan Kaprow and Jim Dine to more recent developments such as process art. Like these other artists, Petry crosses disciplines in order to question their autonomy and their historical relevance to a contemporary context. Usually heroic in scale and sometimes witty and subversive, Petry's installations are usually impermanent—relics, souvenirs and photographic documentation are their only remnants. Major themes in Petry's work include the evolution and introspection of the individual, particularly how those concepts apply to the homosexual male. Michael Petry received a Bachelor of Arts from Rice University, Houston, a master's degree from London Metropolitan University and a doctorate degree from Middlesex University London.

His works are included in the British Museum, London; the Museum of Arts and Design, New York; the Kunst- und Ausstellungshalle der Bundesrepublick Deutschland, Bonn; and the Bellerive Museum, Zurich. Petry is author of *The Art of Not Making: The New Artist/Artisan Relationship*, published by Thames & Hudson in 2012. From 2010 to 2011, Petry was the first artist-in-residence at Sir John Soane's Museum, London, exhibiting two bodies of work, published in *Smoke & Mirrors* in 2011. In 2012, his work was featured in *The Touch of the Oracle* at the Palm Springs Art Museum, which was accompanied by a ten-year career review book distributed by Thames & Hudson. Michael Petry is director and curator of the project space for the Museum of Contemporary Art, London, and guest curator for Futurecity.
**Born in El Paso, Texas, 1960**
**Lives and works in London**

• *Libation to Apollo*, installation, 2014. 24k gold plated porcelain, white wine, 38.4 inches/97.5 cm diameter.

**ROBERT POLIDORI**'s atmospheric photographs of building—exteriors and interiors—altered by the passage of time and the people who have lived in them are investigations into the psychological implications of the human habitat. He has shot all over the world: decaying mansions in the formerly splendid metropolis of Havana; the colonial architecture of Goa; urban dwellings in China and Dubai among other countries; and the *favelas* of Rio de Janeiro. The Metropolitan Museum of Art in New York commissioned him to photograph New Orleans in the wake of Hurricane Katrina and exhibited those photographs in 2006.

Polidori's career as a fine-art photographer began in the early 1980s when he gained permission to document the restoration of the Palace of Versailles. Since then, he has returned to the palace several times to take more pictures, and in each one, his conception of rooms as metaphors and vessels of memory is evident. His tonally rich and seductive photographs are the product of a view camera, long hours waiting for the right light and careful contemplation of the camera angle. Polidori uses large-format sheet film, which he believes produces superior images to digital photography.

Robert Polidori won the World Press Photo of the Year Award in 1998 and the Alfred Eisenstaedt Award for Magazine Photography in 1999 and 2000. He has published eleven books and his work is in the collections of The Metropolitan Museum of Art and The Museum of Modern Art, New York; the Victoria and Albert Museum, London; and the Bibliothèque nationale de France, Paris.
**Born in Montreal, 1951**
**Lives and works in New York**

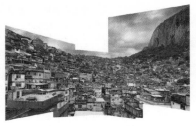

• *Favela Rocinha #1, Rio de Janeiro, Brazil*, 2009. UV-cured ink on aluminum, 9.4 x 14.8 feet/2.9 x 4.5 meters, edition 1/2

With thanks to Galerie Karsten Greve.

**CHATCHAI PUIPIA** produces paintings and sculptures distinguished by their almost confrontational autobiographical style and satirical tone. Primarily known for his oils on canvas, Puipia creates figurative works that express anxiety with Thailand's rapid modernization and the attendant focus on materialism and superficiality.

In 2011, the artist staged his own mock funeral in an exhibition titled *Chatchai Is Dead. If Not, He Should Be*, one example of how he uses humor and parody to reflect the growing dissatisfaction and sense of loss associated with globalization and Thailand's turbulent political factionalism.

Chatchai Puipia received his Bachelor of Fine Arts in Painting from Silpakorn University, Bangkok. Puipia has participated in numerous international exhibitions and biennales, including the 3rd Shanghai Biennale 2000 and the Singapore Biennale 2006. He has exhibited at the Silpakorn University Art Gallery, Art Space and Dialogue Gallery, Bangkok; the Earl Lu Gallery, LASALLE College of the Arts, Singapore; the Espace Pierre Cardin, Paris; the Zentrum für Kunst und Medientechnologie Karlsruhe, Germany; the ISE Cultural Foundation, Asia Society and the Queens Museum, New York; and the Tokyo Metropolitan Art Space.

**Born in Mahasarakarm, Thailand, 1964**
**Lives and works in Bangkok**

• *Life in the City of Angels: War Zone*, 2014. Oil and and pigments on canvas, 70.8 x 61 inches/179.8 x 154.9 cm.

Artist, poet and Tantric guru **SOHAN QADRI** was deeply engaged with spirituality. He abandoned representation early on in his long career, incorporating *Tantric* symbolism and philosophy into his vibrantly colored minimalist works. He began his career in the 1950s painting in oil on canvas, but worked on paper from the 1970s onward. He covered the surface of the paper with structural effects by soaking it in liquid and carving it in several stages with sharp tools while applying inks and dyes. In the process, the paper was transformed from a flat, two-dimensional surface into a three-dimensional medium. The repetition of careful incisions on the paper was an integral part of his meditation—and, in fact, his process evolved out of his desire for an effortless method of creation in tune with his yogic practice.

Qadri was initiated into yogic practice at age seven in India, his birthplace. In 1965, he began a series of travels that took him to East Africa, North America and Europe. After settling in Copenhagen in the 1970s, Qadri participated in more than forty one-man shows, in Mumbai, Vienna, Brussels, London, Oslo, Stockholm, Montreal, Toronto, Los Angeles and New York.

Sohan Qadri's works are included in the British Museum, London; the Peabody Essex Museum, Massachusetts; the Rubin Museum of Art, New York; the National Gallery of Modern Art, New Delhi; the Los Angeles County Museum of Art; the Royal Ontario Museum, Toronto; as well as the private collections of Cirque du Soleil, Heinrich Böll and Dr. Robert Thurman. In 2011, Skira Editore published the monograph *Sohan Qadri: The Seer*.

**Born in Chachoki, Punjab, India, 1932 and died in 2011**
**Lived and worked in Copenhagen and Toronto**

• *Vijaya*, 2010. Ink and dye on paper, 55 x 39 inches/139.7 x 99.1 cm.

• *Suphala III*, 2008. Ink and dye on paper, 55 x 39 inches/139.7 x 99.06 cm.

• *Akriti I*, 2007. Ink and dye on paper, 55 x 39 inches/139.7 x 99.06 cm.

With thanks to a private collector.

Although he's often described as the first and most influential postmodern artist, the unparalleled scope and diversity of **ROBERT RAUSCHENBERG**'s work defies categorization. The acclaimed painter, sculptor, photographer, printmaker and performer was a pioneering figure in contemporary art, employing an unusually wide range of mediums, technique and subject matter in his practice. Rauschenberg established his unique visual vocabulary early on and he soon became known for his use of unexpected techniques and materials. His complex compositions and use of three-dimensional collage blurred the line between painting and sculpture.

Rauschenberg was committed to the notion of collaboration, which resulted in a variety of creative endeavors. He partnered with artists, craftspeople, engineers, writers, composers and performers on a number of projects including the Rauschenberg Overseas Culture Interchange, a huge, traveling exhibition that embodied his belief that artistic collaboration could be a catalyst for social change.

In 1964 Rauschenberg was the first American to win the Grand Prize for painting at the 32nd International Art Exhibition of la Biennale di Venezia, an honor that established him internationally.

Robert Rauschenberg's work has been shown in galleries and museums worldwide, including the Solomon R. Guggenheim Museum and The Metropolitan Museum of Art, New York; the Museum of Contemporary Art, Los Angeles; the Contemporary Arts Museum and the Museum of Fine Arts, Houston; the Peggy Guggenheim Collection, Venice; the Guggenheim Museum Bilbao; Centre Pompidou, Paris; Moderna Museet, Stockholm; Museu de Arte Contemporânea de Serralves, Porto, Portugal; Museum Tinguely, Basel; and the Royal Botanic Garden Edinburgh.
**Born in Port Arthur, Texas, 1925 and died in 2008**
**Lived and worked in New York and Captiva Island, Florida**

• *Giallo Call Glut (Neapolitan)*, 1987. Assembled metal parts with rubber-coated wire, 42 x 47.8 x 7.9 inches/ 106.7 x 121.3 x 20 cm.

With thanks to the Robert Rauschenberg Foundation, Christopher Rauschenberg and David White.

**SEBASTIÃO SALGADO** has made it his life's work to document the impact of globalization on humankind. His black-and-white prints lay bare some of the bleakest moments of modern history as well as some of the planet's last remaining wonders.

In the past three decades, Salgado has traveled to more than one hundred countries for his photographic projects and devotes years to each series in order to grasp the full scope of his topic. Breaking down barriers, he lives with his subjects for weeks, immersing himself in their environments. Salgado describes this approach as photographing from inside the circle. Each of his images is infused with empathy and respect for his subjects. He is best known for three large photographic projects: *Workers*, *Migrations* and *Genesis*, which is his most recent series. Eight years in the making, it pays homage to unspoiled nature. The *Genesis* exhibition, curated by Lélia Wanick Salgado, has been traveling to museums around the world since 2013.

Sebastião Salgado began his career as an economist. It was not until the early 1970s, after his wife and frequent collaborator loaned him a camera, that he embarked on a career as a photographer.

Salgado has had solo shows at the International Center of Photography, New York; the Corcoran Gallery of Art, Washington, D.C.; The Photographers' Gallery, the Barbican Art Gallery and the Natural History Museum, London; and the Royal Ontario Museum, Toronto. Among his many honors, Salgado has been named a UNICEF Goodwill Ambassador and an honorary member of the American Academy of Arts and Sciences.

In 1998 Sebastião and Lélia Salgado founded the non-profit Instituto Terra, an organization focused on reforestation and environmental education. Since the 1990s, they have been restoring a portion of the Atlantic Forest in Brazil.
**Born in Aimorés, Minas Gerais, Brazil, 1944**
**Lives and works in Paris**

• *Iceberg between Paulet Island and the South Shetland Islands in the Weddell Sea, Antarctic Peninsula*, 2005. Gelatin silver print, 50 x 68 inches/ 125 x 180 cm.

• *Church Gate Station, Bombay, India*, 1995. Gelatin silver print, 50 x 68 inches/ 125 x 180 cm.

Emerging artist **NINO SARABUTRA** studied Ceramic Arts at Silpakorn University in Bangkok. She has continuously honed her skills as a ceramist since setting up her Bangkok studio in 2006. Sarabutra has been exhibiting since 2008, with her first solo show, *Exploring Love*, focusing on themes of human emotion and existence.

For her most recent project, *What Will You Leave Behind?* from 2013, Sarabutra created 100,000 palm-sized porcelain skulls. The artist asked friends, family, neighbors, students and colleagues to help create the skulls and while making them, they were asked to contemplate their lives and think about what they would leave behind. Once installed on the floor, viewers leave their shoes at the door and walk across the carpet of skulls contemplating the fragility of life and inevitability of death.

Nino Suwannee Sarabutra has exhibited at Dao Art Space, Xi'an and the Fule International Ceramic Art Museums, Weinan, Shaanxi Province, China; MEINBLAU project room, Berlin; Creative House Bangkok, Ardel's Third Place Gallery, and the Rotunda Gallery in the Neilson Hays Library, Bangkok; ENJOY-Studio 5, Phuket, Thailand; The Art Academy, London (where she also held lectures as the ceramics-artist-in-residence) and the Quay Art Centre, Isle of Wight.

**Born 1970 in Ubonratchathani, Thailand**
**Lives and works in Bangkok**

• *What Will You Leave Behind?*, installation, 2012. Unglazed porcelain skulls, 4.5 x 45.5 feet/1.4 x 14 meters.

**HIROSHI SENJU** is noted worldwide for his sublime waterfall images, often monumental in scale, many of which are installed in public spaces. He combines a minimalist visual language rooted in Abstract Expressionism with ancient painting techniques unique to Japan. He is widely recognized as one of the few contemporary masters of the thousand-year-old *nihonga* style of painting, using pigments made from minerals, ground stone, shell and corals in animal-hide glue.

With incredible delicacy, he pours translucent paint onto mulberry paper mounted on board, creating the sensation of unrestrained movement. In 2007 and again in 2015, he used fluorescent pigments instead. These images, including immense multi-panel folding screens, appear black and white in daylight and electric blue under ultraviolet light.

Hiroshi Senju was the first Asian artist to receive an Honorable Mention Award at the International Art Exhibition of la Biennale di Venezia, 1995, and has participated in exhibitions including the *Beauty Project* in 1996 at the Museum of Contemporary Art, London; *The New Way of Tea*, curated by Alexandra Munroe, at the Japan Society and the Asia Society in New York in 2002; and *Paintings on Fusuma*, at the Tokyo National Museum in 2003. Public installations include seventy-seven murals at Jukoin, a sub-temple of Daitokuji, a Zen Buddhist temple in Japan and a large waterfall at Haneda Airport International Passenger Terminal in Tokyo. The Benesse Art Site of Naoshima Island also houses two large-scale installations.

Senju's work is in the Museum of Contemporary Art in Los Angeles; The Museum of Modern Art, Toyama, Japan; the Yamatane Museum of Art, Tokyo; Tokyo University of the Arts; and the Kushiro Art Museum, Hokkaido, Japan. In 2009, Skira Editore published a monograph of his work titled *Hiroshi Senju*. The Hiroshi Senju Museum Karuizawa, designed by Ryue Nishizawa, opened in 2011 in Japan.

**Born in Tokyo, 1958**
**Lives and works in Pleasantville, New York**

• *Ryujin I* (day), 2014. Acrylic and fluorescent pigments on Japanese mulberry paper, 7.9 x 37.4 feet/ 2.4 x 11 meters.

• *Ryujin I* (night).

• *Ryujin II* (day), 2014. Acrylic and fluorescent pigments on Japanese mulberry paper, 7.9 x 37.4 feet/ 2.4 x 11 meters.

• *Ryujin II* (night).

• *Suijin*, 2015. Natural pigments on Japanese mulberry paper mounted on board, three panels each 8.5 x 6.4 feet/ 2.6 x 2 meters.

Painter, printmaker and sculptor **DONALD SULTAN** has been at the forefront of contemporary art since the 1970s. He is best known for challenging conventions of materiality and technique, transforming Western traditions of painting into a contemporary venture. Sultan says his work, often categorized as still-life painting, is first and foremost abstract. His instantly recognizable silhouettes of fruit, flowers and lemons, among other objects, set against large-scale black backgrounds assert the power of form. He incorporates geometric and organic shapes into his work and places equal emphasis on both negative and positive spaces, enabling an element of ampleness to translate to viewers. Juxtaposing traditional approaches to painting with unique materials, Sultan uses industrial plaster, tar, Spackle and enamel. Creating layers on Masonite instead of canvas, he strips away sections, outlining and embossing his shapes and forms before painting over them. Sultan describes his work as "heavy structure, holding fragile meaning" and it hovers between industry and nature. Donald Sultan received his Bachelor of Fine Arts from the University of North Carolina at Chapel Hill, and his Master of Fine Arts from the School of the Art Institute of Chicago. In 2002 he was a visiting artist-in-residence at the Singapore Tyler Print Institute. His work is included in the permanent collection of The Museum of Modern Art and The Metropolitan Museum of Art, New York, and the Dallas Museum of Art, Texas. A monograph of Sultan's thirty-year career *Donald Sultan: Theater of the Object* (The Vendome Press) was published in 2008. In 2010 Sultan was honored with the North Carolina Award, the highest honor the state can bestow on a citizen.
**Born in Asheville, North Carolina, 1951**
**Lives and works in New York**

• *Black and Whites Jan 20 2015*, 2015. Enamel, tar and Spackle on tile over Masonite, 96 x 96 inches/ 243.8 x 243.8 cm.

**JACK TWORKOV** was born in Poland and immigrated to the United States when he was thirteen. Aspiring to become a writer, he attended Columbia College as an English major, but after encountering the work of Paul Cézanne and Henri Matisse for the first time, Tworkov decided to pursue painting instead. He studied under Ivan Olinsky and Charles Hawthorne at the National Academy of Design and Guy Pène du Bois and Boardman Robinson at the Arts Students League of New York. A founding member of the New York School in the early 1950s, along with Willem de Kooning, Philip Guston, Jackson Pollock and Franz Kline, Tworkov was a driving force behind the Abstract Expressionist movement in America. Although best known for his dramatic, gestural paintings produced in the 1950s, Tworkov refused to be defined by any one style. In addition to Abstract Expressionism, Tworkov also explored Social Realism and by the late 1960s he embarked on a more contemplative period, employing the grid-like structures and geometric forms of Minimalism. During his fifty-year career, Tworkov never really left writing behind and his work is often shown alongside some of his personal and teaching journals, letters to other artists, published articles and previously unpublished essays.
Jack Tworkov's works are in noted private and public collections worldwide, including The Museum of Modern Art, the Whitney Museum of American Art, The Metropolitan Museum of Art, the Solomon R. Guggenheim Museum, and the Jewish Museum, New York; the San Francisco Museum of Modern Art; the Smithsonian American Art Museum, the National Gallery of Art, the Corcoran Gallery of Art and the Hirshhorn Museum and Sculpture Garden, Washington, D.C.; the Provincetown Art Association and Museum, Massachusetts; and the Tate Modern, London.
**Born in Biala Podlaska, Poland, 1900 and died in 1982**
**Lived and worked in Washington, D.C.; New Haven, Connecticut; and New York**

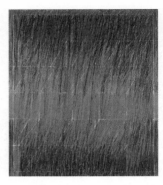

• *Crossfield 1*, 1968. Oil on canvas, 80 x 70 inches/203.2 x 177.8 cm.

With thanks to Hart Perry.

**LEE WAISLER** creates dimensional portraits of historical and contemporary figures composed of strips of wood and blocks of color. He layers his canvases with thick pigments, followed by the addition of organic materials that hold symbolic value: sand for time, wood for life, and glass for light. His range of materials creates dynamic forms and textures.

Waisler began painting in the 1960s. His earliest works were socially and politically charged, dealing with momentous historical events such as the Holocaust, the Vietnam War and the civil rights movement. Waisler's works soon began to reflect his growing interest in Eastern philosophy, and accordingly, became increasingly abstract. It was after a journey to India in the mid-1990s that his works moved away from pure abstraction toward figuration. He turned to portraiture full-force in 2005. His subjects include iconic individuals from many spheres, including Nelson Mandela, Aung San Suu Kyi, Albert Einstein, Eleanor Roosevelt and Mahatma Gandhi.

Lee Waisler's work is included in The Metropolitan Museum of Art, New York; the Victoria and Albert Museum, London; the Tel Aviv Museum of Art; the Brooklyn Museum; the Smithsonian Institution, Washington, D.C.; Bibliothèque nationale de France, Paris; the National Gallery of Modern Art, New Delhi; and the Indian Museum, Kolkata.

**Born in Los Angeles, 1938**
**Lives and works in Los Angeles**

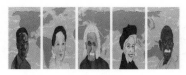

• *Five in the World*, 2014. Acrylic and wood on canvas, 6 x 15 feet/1.8 x 4.6 meters.

An influential member of the New York School, **SUSAN WEIL** combines unexpected materials—including collage, blueprint and paint on recycled canvas, acrylic and wood—to create dimensional works exploring the passage of time and movement. She often fractures the picture plane, deconstructing and reconstructing images.

Susan Weil came of age as an artist in the postwar period, studying under Josef Albers at Black Mountain College alongside Willem and Elaine de Kooning, Jasper Johns, Robert Rauschenberg and Cy Twombly. But unlike her contemporaries, Weil has never been afraid to pursue figuration and reference reality, drawing inspiration from nature, literature, photographs and her personal history, embracing serious and playful elements in her work. Weil is the recipient of a John Simon Guggenheim Memorial Foundation Fellowship and a National Endowment for the Arts Fellowship. Her work is included in The Metropolitan Museum of Art and The Museum of Modern Art, New York; the Victoria and Albert Museum, London; the J. Paul Getty Museum, Los Angeles; Nationalmuseum, Stockholm; Helsinki City Art Museum; and Museo Nacional Centro de Arte Reina Sofía , Madrid. In 2010, Skira Editore published *Susan Weil: Moving Pictures*, a comprehensive monograph documenting her large and diverse body of art, *livres d'artistes* and poetry.

Thirty years of Susan Weil's poems and drawings were on view at Black Mountain College Museum + Arts Center in Asheville, North Carolina, in the first half of 2015.

**Born in New York in 1930**
**Lives and works in New York**

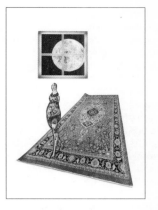

• *Body Shelley*, 2014. Digital image on backlit Plexiglas and canvas on Sintra board, 77 x 55.5 x 2 inches/ 195.6 x 141 x 5.1 cm.

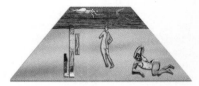

• *Jones Beach*, 2014. Digital image on canvas and Sintra board, 30 x 72 x 2.5 inches/76.2 x 182.9 x 6.4 cm.

**MORGAN WONG**'s practice focuses on durational performance. He is interested in the irrepressibility of time and challenging social and political norms. After completing a Master of Fine Arts degree focusing on sculpture at Slade School of Fine Art, he began to apply sculptural practice to his work.
Notable projects include the award-winning installation *Alliance*, 2007, which combined a motion-tracking system with a word database directed by the viewer's movement. Represented by Chinese characters projected onto a screen, the word relationships could be created or destroyed, depending on the viewer's activity. In 2013, Wong began the ongoing work *Filing Down a Steel Bar Until a Needle Is Made,* which was shown at the 8th Shenzhen Sculpture Biennale. Inspired by a traditional Chinese allegory on one's determination and volition, he confined himself to a room for forty-eight hours and began the monotonous task of filing down a steel bar (measured to his height and weight) to the size of a sewing needle.
Wong's work has been exhibited around the world, including at the Tate Modern, London; the Hong Kong Museum of Art and Para Site, Hong Kong; the Gwangju Museum of Art, Korea; the ZKM | Media Museum, Karlsruhe, Germany; Soka Art Center, Taipei; the Fremantle Art Centre, Australia; 18th International Contemporary Art Festival Sesc_Videobrasil and Liste 17, Basel. In 2014, the artist showed *The Remnant of My Volition (Force Majeure)* at Art Basel Hong Kong's Encounters section, curated by Yuko Hasegawa. In 2015 his work will be included in the inaugural exhibition of the Shanghai 21st Century Minsheng Art Museum (M21).
**Born in Hong Kong, 1984**
**Lives and works in Hong Kong**

• video still from *The Remnant of My Volition (Force Majeure)*, 2014. HD, color, no sound, 72 minutes, 8 seconds.

With thanks to Pearl Lam Galleries.

**ROBERT YASUDA** composes subtly iridescent paintings suffused with luminous color. Yasuda investigates the fugitive qualities of light and human perception by layering acrylic paint and sheer, woven fabric atop sculpted wooden panels. Yasuda builds surfaces that are at once ethereal and architectural. His works assume different guises according to changes in light and the viewer's vantage point. Defying the traditional boundaries of painting, Yasuda's works possess a floating quality. He carves wooden panels into unusual forms with sharp upturned corners, softly rounded edges or subtly curved contours. Attaching covert cradle-like wooden structures behind several paintings, he forces the works forward into space giving them a distinctly sculptural quality. In other cases, he suspends his works from narrow supports creating dramatic T-shaped compositions. Yasuda is continuously rebelling against the conventional painting frame and introducing new means of context and framing.
Yasuda moved to New York in the late 1950s where he attended the Pratt Institute. He began exploring themes of perception, light and nature in the early 1970s, producing resoundingly abstract paintings. He would dry the delicately layered canvases under the scorching sun in Florida, where he still spends half the year painting in the Keys. Increasingly, he became fascinated with the different character of his works when viewed in natural light versus artificial light.
Robert Yasuda has been recognized with awards from the National Endowment for the Arts and the American Academy of Arts and Letters. His works are in the permanent collections of the Brooklyn Museum; the Library of Congress, Washington, D.C.; the New York Public Library; the Bass Museum of Art, Miami, Florida; Carnegie Institute, Pittsburgh, Pennsylvania; and the McNay Art Museum, San Antonio, Texas.
**Born in 1940 in Lihue, Hawaii**
**Lives and works in New York**
**and Sugarloaf Key, Florida**

• *Element*, 2014. Acrylic on fabric on wood, 10.1 x 1.5 feet/3.1 x 0.46 meters.

**CHUN KWANG YOUNG** produces sculptural compositions made from small, hand-cut bits of Styrofoam wrapped in antique mulberry paper sourced from Korean periodicals and academic texts that have been tinted with teas, fruits and flowers. Often massive in scale, Chun's highly tactile sculptures and three-dimensional canvases are embedded with Korean tradition and history while articulated in a contemporary visual language. Although he began his career as a painter, Chun started to experiment with paper sculpture in the mid-1990s and over time his work has evolved in complexity and scale. The development of his signature technique was sparked by a childhood memory of seeing medicinal herbs wrapped in mulberry paper tied into small packages. Chun's work subtly merges the techniques, materials, and traditional sentiment of his Korean heritage with the conceptual freedom he experienced during his Western education.

Chun Kwang Young received a Bachelor of Fine Arts from Hongik University, Seoul and a Master of Fine Arts from the Philadelphia College of Art, Pennsylvania. His work is in numerous public collections, including The Rockefeller Foundation and the United Nations, New York; the Woodrow Wilson International Center for Scholars, Washington, D.C.; the Philadelphia Society Building, Pennsylvania; the National Museum of Modern and Contemporary Art, Seoul, and the Seoul Museum of Art; the National Gallery of Australia, Canberra; the Victoria and Albert Museum, London; and the National Museum of Fine Arts, Malta.

He was named Artist of the Year by the National Museum of Modern and Contemporary Art, Seoul, in 2001 and in 2009 he was awarded the Presidential Prize in the 41st Korean Culture and Art Prize by the Ministry of Culture, Sports and Tourism.

**Born 1944 in Hongchun, Korea**
**Lives and works in Seongnam, Korea**

• *Aggregation 8*, 2008. Mixed media with Korean mulberry paper, 142.5 x 79 inches/362 x 201.9 cm.

• *Aggregation 12*, 2012. Mixed media with Korean mulberry paper, 63.6 x 89.3 inches/161.5 x 226.8 cm.

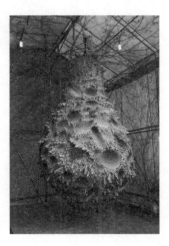

• *Aggregation 15*, 2015. Mixed media with Korean mulberry paper, 11.5 x 6.6 x 3.3 feet/3.5 x 2 x 1 meter.

## THE LEGACY OF RABINDRANATH TAGORE

Tagore Foundation International, under whose auspices *Frontiers Reimagined* has been organized, is deeply committed to the ideals of Rabindranath Tagore (1861–1941), whose vast body of poetry, literature, music, dance and dramas are infused with humanism and universalism.

Tagore, who was born in Calcutta into a creative family that shaped the cultural life of India, was a proponent of dialogue between the East and West long before it was fashionable to think beyond one's geographical or cultural borders. It was at his behest that the first exhibition of Bauhaus art ever to travel outside Germany came to India in 1922. This exhibition, which included the work of Wassily Kandinsky, Paul Klee and Lyonel Feininger, changed the course of Indian modernism, particularly as it was expressed through the works of the Bengal School, an artistic movement Tagore helped forge with members of his family, including his nephew, Gaganendranath Tagore (1867–1938).

Truly a creative being, Tagore picked up a paint brush at the age of sixty-seven and produced an astonishing number of works. He was the first Indian artist to exhibit his art throughout Europe, Russia and the United States. He painted imaginary creatures, landscapes, figures and most notably, haunting faces, in a bold, expressionistic manner. He traveled extensively and his relationships with artists of his day, including Edward Munch, Kandinsky and native Canadian artisans, are evident in his work. He developed a syncretic style all his own, combining elements from classical Indian art, Western modernism and the ink and brush techniques of the East.

Rabindranath Tagore was awarded the Noble Prize in literature in 1913, the first non-Westerner to be so honored. In 1921, with the benefit of that recognition, he turned Santiniketan, an ashram outside Calcutta, into a world university, Visva-Bharati, bringing together some of the most influential thinkers of the 20th century.

This globalism was the inspiration for this exhibition.

**Gaganendranath Tagore**
untitled (portrait of Rabindranath Tagore), ca. 1910. Watercolor on paper, 10 x 7 inches/26 x 17.8 cm.

**Rabindranath Tagore**
untitled (riders in night), ca. 1938. Ink and color on paper, 5.9 x 5.1 inches/ 15 x 13 cm.

**Rabindranath Tagore**
untitled (dragon), ca. 1930s. Watercolor on paper, 8.1 x 12 inches/20.5 x 29.5 cm.

With thanks to Nirmalya Kumar and Maya Kumar.

A portrait of Rabindranath Tagore by Sir Jacob Epstein (1880-1959), conceived in 1926. Bronze, 30 x 13 inches/76.2 x 33 cm.

**TAGORE FOUNDATION INTERNATIONAL** is a nonprofit organization devoted to intercultural dialogue based in New York City.
It is committed to arts education and the promotion of social, spiritual and aesthetic dialogues between Asia and the West.
The goals of Tagore Foundation International were inspired by and are deeply enmeshed with the ideals of Rabindranath Tagore, whose poetry, fiction, music and art have touched the lives of people all over the world.
Tagore's ideals of humanity's greater good are embodied in the following:
"I slept and dreamt that life was joy. I awoke and saw that life was service. I acted and behold, service is joy."
Rabindranath Tagore worked tirelessly throughout his life encouraging his fellow man to break free from "narrow domestic walls" through social justice and a universalism that merged the best ideals of East and West. His well-known dialogues with other great thinkers of his era, including Gandhi, Albert Einstein, Romain Rolland and W.B. Yeats, centered on universalism and the fundamental dignity of human existence.
Inspired by this heritage, support for education is a major component of the foundation's activities. The foundation has provided scholarships for students in India and Mozambique and a permanent scholarship fund at the College of Wooster, Ohio in the United States for the education of disadvantaged young women. The foundation also actively organizes and sponsors cultural events in the United States, Hong Kong and Singapore that encourage intercultural dialogue.

www.tagorefoundationinternational.com

**SUNDARAM TAGORE** is an art historian, gallerist and award-winning documentary filmmaker. He was born in Calcutta in 1961 and divides his time between New York City, Hong Kong and Singapore.
A descendant Rabindranath Tagore, he promotes East-West dialogue through Tagore Foundation International, a nonprofit cultural organization he founded and directs, and his eponymous art galleries and their multicultural and multidisciplinary events.
Before opening his own gallery in 2000 in New York City, he was a director at Pace Wildenstein Gallery. He has also advised and worked with many international organizations including the National Gallery of Modern Art, New Delhi; The Metropolitan Museum of Art and The Museum of Modern Art, New York; and the United Nations. A candidate for a Doctorate of Philosophy from the University of Oxford, Tagore also writes for numerous art publications. His articles have appeared in *ARTnews*, *Art in America* and *Art India*. He also lectures frequently on art.
Tagore's debut film, *The Poetics of Color: Natvar Bhavsar, An Artist's Journey*, premiered at the MIAAC Film Festival in New York City in 2010 and has since garnered several festival awards. The film has been shown at venues around the world, including the Hong Kong Arts Centre, the Asian Art Museum of San Francisco, the Los Angeles County Museum, the Newport Beach Film Festival and the India International Centre in New Delhi. He is currently making his second film, a feature-length documentary on the architect Louis I. Kahn.

**MARIUS KWINT** is an art historian, born in Sacramento, California, in 1965. He teaches Visual Culture at the University of Portsmouth. A graduate of the universities of Aberdeen and Oxford, he has held research fellowships at the Houghton Library, Harvard University, and jointly at the Royal College of Art and the Victoria and Albert Museum, London. Between 1999 and 2008 he was a lecturer in the History of Art at the University of Oxford, where he was elected fellow of St. Catherine's College. His interests include the relationship of science and art, and he was a guest curator of the major exhibition *Brains: the Mind as Matter* at the Wellcome Collection, London in 2012.

Printed by
Graphicom s.r.l., Vicenza
for Marsilio Editori s.p.a., Venice